Exterior|*Interior* **ALICE NEEL**

TUFTS UNIVERSITY ART GALLERY

October 1 – December 20, 1991

This catalog has been published in conjunction with *Exterior/Interior: Alice Neel,* an exhibition organized by the Tufts University Art Gallery with support from the Ann and Steven Ames Exhibition Fund. The exhibition represents the inaugural presentation in the Tisch Family Gallery of the new Aidekman Arts Center on Tufts' Medford/Somerville Campus.

© Tufts University Art Gallery
Published by Tufts University Art Gallery
Aidekman Arts Center
Medford, Massachusetts 02155
Printed in the United States

Library of Congress
Cataloging-in-Publication Data
ISBN 1-880593-00-9

Allara, Pamela.
Alice Neel, Exterior/Interior/Pamela Allara
p. cm.
Catalog of an exhibition held at Tufts
October 1 to December 20, 1991.
Includes bibliographical references.
1. Neel, Alice, 1900 – Exhibitions
2. Feminism and the arts – New York (NY)
I. Neel, Alice, 1900
II. Tufts University Art Gallery
III. Title

ND237.N43A4 1991
759.13 – dc20
91-34091
CIP

Distributed by
D.A.P./Distributed Art Publishers
636 Broadway, Suite 1208
New York, NY 10012
1-800-338-2665
Fax: 212-637-2887

Tufts University Art Gallery is pleased to present *Exterior/Interior: Alice Neel*. The exhibition and catalog represent an important contribution to scholarship on Alice Neel by focusing on an area of her creative production not often considered in the extensive literature on the artist. Perceived primarily as a portrait painter, Neel to the contrary created a significant body of still lifes, landscapes, and cityscapes that have rarely been shown. With this exhibition and catalog we hope to redress the narrow view of Neel's career and expand our knowledge of this important American artist. The fertile field of expression seen in the painter's non-portrait work, free from the pressure of capturing a likeness or personality, deepens our understanding of Alice Neel's development and reveals a long-neglected aspect of her achievements as an artist.

Plans for the project have taken a long and circuitous route. Realization of the exhibition is due to the intercession of many interested parties who saw it as a fitting inaugural for the Tisch Gallery in the new Aidekman Arts Center at Tufts' Medford campus. Dr. Hartley Neel, the artist's son and a graduate of Tufts Medical School, provided a crucial and early link with the university. Edward Merrin, trustee of Tufts and a member of the Arts Board of Overseers, and Laura Bernard of the university's Development Division have played helpful roles in soliciting support for the exhibition and catalog. Nancy Neel and Richard Neel have graciously made available materials in the Alice Neel archives and have provided valuable information throughout all phases of the project. John Cheim, Director, and Wendy Williams, Registrar, at Robert Miller Gallery have been most cooperative in allowing access to Neel's works on deposit at the gallery and have graciously provided photographs for study and for this publication. Many thanks to Erika Ketelhohn-Askin, my predecessor as Acting Gallery Director, and to Catherine Mayes, then a graduate student in art history, who were key participants in the early stages of the project. Pamela Krupanski, slide curator in the Department of Art History, and her staff Cheri Coe and Chris Cavalier were most helpful in the production of visual materials related to the exhibition and catalog. Suzanne Perry and Fred Kalil of Tufts Office of Communications and Public Relations and Alison Kennedy and Margaret Bauer at WGBH Design expertly guided the design and production of the catalog. My assistant, Nancy Chute, played an important role in the preliminary organization of the exhibition and, more recently, safely brought the works to Tufts and participated in their installation in the gallery.

A sincere thank you to Pamela Allara, guest curator for the exhibition, whose dedication to Neel and to the exploration of this overlooked part of the artist's career has been unwavering. She has enjoyed the opportunity to discuss Neel's work with collectors such as Arthur Bullowa and Peggy Brooks, for whom living with Neel's paintings has been so rewarding. Additional useful information and suggestions were provided by Patricia Hills, Rudolf Baranik, and May Stevens. Finally, on behalf of Pamela Allara and the entire university community, I thank the lenders to the exhibition for their generous cooperation in allowing us to bring their pictures to a wider public and present a facet of Alice Neel's career that merits discourse.

Elizabeth Wylie
Director, Tufts University Art Gallery

Object as Metaphor in Alice Neel's Non-Portrait Work

INTRODUCTION

"I always used to tell them I'm an old-fashioned painter – still lifes, country scenes, and people. People have been my overriding interest."[1] Alice Neel (1900 – 1984) is known today for her incisive portraits of the famous, infamous, and anonymous denizens of New York City. Unfortunately, her art has been pigeonholed into the category of portraiture, with the resulting neglect of the full range of her work. Neel's own strong personality, as well as the riveting psychological presence she extracted from her sitters, has led to the skewing of critical attention to her personal life and to the personalities of the people she painted rather than to Neel's contribution to the history of art. Alice Neel was not simply a specialist in a genre rendered anachronistic by the advent of photography; she takes rank with the best of American twentieth-century painters. By exhaustively presenting a lesser known aspect of the artist's oeuvre, this exhibition and essay is intended to present a more balanced assessment of Neel's achievement.

Although Neel spoke about her non-portrait work as a respite from the trials of portraiture, it never served as a purely formal exercise for her. Her inanimate objects – table tops or building facades – serve as tablets on which to inscribe metaphors for her life experience. In some instances the work was generated by highly emotional events in her life; however, this essay will focus on her creative use of visual metaphor rather than on her biography. Through this approach I hope to construct a picture of a woman artist who recorded her immediate, mundane surroundings – her dwelling and the objects in it – in order to wrest the widest possible human significance from her thoughts, feelings, and experience. Neel's art confirms Georges Braque's observation that "our emotions are less about the object itself than about the history of our minds' engagement with the object."[2] Working alone, she made an art of connection, one which recognizes that the self is defined by others, whose history is written into the objects that surround us. "Exterior" and "interior" are not opposed terms in her work; rather, one presupposes the other.

Although Neel had to wait until she was in her sixties before she began to receive critical recognition as an artist, her non-portrait work remained in the shadows until the 1980s. Neel always included still lifes and cityscapes in her gallery exhibitions, but a fateful decision on the part of the Whitney Museum of American Art aggravated the perception of her work which had been created by most of the critical writing since the early 1960s. In 1974, in part as the result of pressure from feminist artists and critics, the Whitney granted the seventy-four-year-old Neel her first museum retrospective. However, at initial planning stages, the director, John I. H. Baur, made the decision that the "retrospective" would include only her portrait work.[3] Thus the most important official recognition Neel received during her lifetime reinforced her reputation as a portrait painter.

Neel's non-portrait work was not exhibited on its own until 1982, when John Cheim, the director of the Robert Miller Gallery in New York City, organized "Alice Neel: Non-Figurative Works, Still Lifes, Cityscapes, Landscapes, Interiors" (May 4 to June 5, 1982). This important show contained twenty-nine works and was favorably reviewed in all of the major art periodicals. John Russell of the *New York Times* wrote that "it is an unfamiliar Miss Neel we see in this show."[4] Writing in *Arts* magazine, Jon R. Friedman observed that "...the notoriety of the portraits has led to the neglect of the large body of still lifes and landscapes Neel has painted throughout her career...."[5] Deborah Phillips of *ARTnews* concluded that "the non-portrait work [is] every bit as complex and psychologically compelling as the portraits."[6] However, since Neel's death in 1984, the critical writing on Neel has not expanded on any of the ideas stimulated by this exhibition, perhaps in part because Neel's art does not precisely "fit" current definitions of post-modernism any more than it can comfortably be categorized as modernist. And so, nearly a decade after the Miller gallery exhibition, Neel's reputation still rests primarily on her portraiture, and her work continues to be conflated with her biography.

Neel's description of herself as old-fashioned reveals an insight into her art as telling as the psychological traits she laid bare in her portraits. Trained in Philadelphia in the American realist tradition born in the early nineteenth century at the Pennsylvania Academy, Neel's style and subjects were also rooted in nineteenth-century French painting. Categorizing herself as a "realist-expressionist," Neel combined in her art the conventions of the American "Ashcan School" and its precedents in the French nineteenth-century realism of Degas and Manet, with the expressionism of Van Gogh and the German Expressionists. Unlike an artist such as Picasso, who from 1908 on reinvented Western conventions of representation through the genres of still life, portraiture, and landscape, Neel never adopted a combative attitude toward tradition. The means by which she would achieve visual interest, her "brief," to use Michael Baxandall's term,[7] was not stylistic innovation, but a molding of stylistic convention and thematic material so that it held non-traditional content. Unfortunately, although the reviewers of the 1982 exhibit respected her traditionalism, they failed to adequately analyze the unique content of her work, and thus damned her with faint praise as an adept pastiche artist. John Russell wrote: "In particular, we realize that she has kept a sharp eye on the 20th-century tradition, whether in this country or elsewhere...we see in Miss Neel a one-person repository of themes that were worth rescuing from the art of the last 100 years...."[8] In his review, the painter and critic Robert Storr revealed the underlying communal bias against tradition in an epoch which extolled artistic originality.

...often the mood of the paintings is established around subjects that are in themselves...downright clichéd: a tenement at night, the sea under the moon, objects and flowers on a table...what commands one's respect, in fact, is the energy with which she attacks such set pieces.[9]

Russell's and Storr's commentary points to a major reason for Neel's continuing lack of recognition in the standard histories of twentieth-century American art: "...it is her involvement with traditions and conventions that has held back the broader acceptance she so clearly deserves."[10] As feminist art historians have pointed out, bias against tradition is frequently synonymous with bias against art by women. In response to statements such as, "Women painters as everyone knows always imitate the work of some men" (R. H. Wilenski), Lucy Lippard has countered:

Within the old, 'progressive,' or evolutionary contexts, much women's art is 'not innovative,' or 'retrograde.'...One of the major questions facing feminist criticism has to be whether stylistic innovation is indeed the only innovation, or whether other aspects of originality have yet to be investigated...perhaps women... [differ] from the traditional notion of the avant-garde by opposing not styles and forms, but ideologies.[11]

Neel's art provides an ideal vehicle for testing this assertion.

EXTERIOR: CITYSCAPES AND LANDSCAPES

Neel never enjoyed, nor sought, luxury housing in New York City; for the better part of her adult life she lived in poor, crime-ridden neighborhoods. No matter where she lived, the view out the window was that faced by the majority of New Yorkers: the vertical facade of the apartment building across the street or alley. Over the course of fifty years, Neel's art presented – without maudlin narrative – the psychological effects of living in a tenement. The severity and claustrophobia of her architectural paintings are mitigated, even complemented, by the more expansive organic shapes of her landscapes, which frequently record sites near her apartments, either along the Hudson or Harlem Rivers or in Central Park. "Architecture" and "landscape" are frequently subsumed in her art under the broader category of "urban life."

In 1927, Alice Neel arrived in New York from Cuba, where she had spent the first year and a half of her marriage to the Cuban painter Carlos Enriquez. Over the next eleven years Neel lived in four different locations in the city, spanning the island from the South Bronx to Greenwich Village. During 1927, she lived on West 81st Street, and from the winter of 1928 to the spring of 1930 at 1725 Sedgwick Avenue in the Bronx.

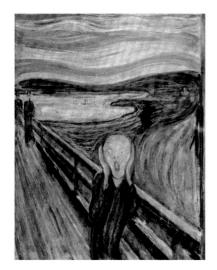

Figure 1
The Scream 1893
Edvard Munch
mixed media on cardboard
35 7/8 x 29"
Galleria Nazionale, Oslo

When in 1932 she returned to the city after a hiatus in Philadelphia, she lived on 33 Cornelia Street (off Bleeker) in Greenwich Village, and then, from 1934 to 1938, with some brief interruptions, on West 17th Street.

In 1938, she moved some ninety blocks north to Spanish Harlem to raise the child, Richard, she bore Jose Santiago, a Puerto Rican musician and Spanish teacher. (A second child, Hartley, fathered by Russian photographer/filmmaker Sam Brody, was born in 1941.) Here, at least in terms of her living quarters, her life became more settled, although a charming painting from 1938 depicts Neel's departure from the intellectually stimulating milieu of Greenwich Village as a *Flight into Egypt*. The two apartments which she occupied in Spanish Harlem were only one block from each other: from 1938 to 1943, she lived on 10 East 107th Street, and from 1943 to 1962 on 21 East 108th Street. When Neel moved out of Spanish Harlem in 1962, she went only a few blocks west, and until her death in 1984 lived on 300 West 107th Street on upper Broadway near Columbia University.

Although each location had its distinct character, they were all, from Neel's point of view, domiciles. In Neel's painting, urban architecture is domestic architecture. She never extolled the famous landmarks, the skyscrapers and bridges, so frequently recorded by her modernist compatriots such as John Marin, Joseph Stella, and Charles Sheeler. Nor does she record the panoramic vistas found in much of the "straight" photography of artists such as Berenice Abbott or Alfred Stieglitz. Not monuments, but vernacular buildings, the anonymous five- to six-story apartment buildings and row houses built in the first two decades of the century to accommodate the city's swelling population. Not vistas, but individual buildings, containers for a diverse group of people. Neither the city as dynamic energy, nor as powerful abstract design, nor as stage setting for the human dramas of street life. Despite the fascination New York has held for American artists, few have so consistently characterized the city experience in terms of the isolation of strangers housed in close proximity.

EARLY WORK, 1927–30: THE DEVELOPMENT OF METAPHOR

Neel's early work, much of which is in watercolor, is directly autobiographical, frequently depicting scenes relating to the emotional traumas of those years: the tension in her marriage and the loss of two children. Although the narrative aspect of these watercolors places them in a separate category from the depopulated cityscapes and landscapes after 1930, they are included here because they establish the pattern of interweaving her environment and her feelings, which is a constant in her work. Her earliest watercolors are already expressionist in form and content, and before she had heard of either the Scandinavian or German Expressionists, she had established herself as the American Edvard Munch.[12]

After the Death of the Child was made in 1927, shortly after Alice and Carlos lost their year-old daughter, Santillana, to diphtheria. It depicts the park area near the 79th Street boat basin, a few blocks from their apartment on West 81st Street. In this work she translated the feelings of intense isolation from normal life one feels after suffering trauma and loss: the stiff black vertical of the pedestrian stands apart in color and shape from the mobile group of children in their enclosed playground. The schematic drawing carries the message directly by reducing the objects to symbols: the leafless tree, the unarticulated building facades, and the (sexless/lifeless) figure contained in a void. In *Requiem* (1928), also a memorial to her daughter, undulating streaks of wet grey wash evoke the restlessness of the sea after a storm, while along the shore at the bottom edge, toe to head, lie two skeletal figures, pressing hand to skull in the same tortured gesture of emotional dispair found in Munch's *The Scream* (1893, fig. 1).

Munch was able to forge his vision from the precedent of Van Gogh, but in the 1920s Neel would not have had the opportunity to see either artist's work. Although Munch was shown in the Armory Show of 1913, his paintings were not exhibited in this country again until 1950.[13] Nor could she have seen an original Van Gogh until the opening exhibition of the Museum of Modern Art in 1929. Moreover, unlike many of her male contemporaries, Neel did not have the opportunity to see modern art firsthand in Europe; the one traveling scholarship at her school was granted to her friend Rhoda Medary.[14] At best she looked at modern art in books and magazines, or went to galleries such as Alfred Stieglitz' Intimate Gallery, which exhibited the work of American artists who had had direct contact with European modernism. Whatever the case, the painter from a provincial town outside of Philadelphia with a conventional art-school training had, on first arriving in New York, made work which was anything but traditional or old-fashioned in terms of American modernist art of the 1920s.

Of all of her American contemporaries, Neel's early watercolors are closest in emotional tenor and technique to Charles Burchfield's equally original watercolors made in Salem, Ohio and Buffalo, New York between 1916 and 1926, and exhibited in New York in 1929 and again in 1930. *The Mysterious Woods,* from 1919 (fig. 2), employs the same reduced pictorial vocabulary to emphasize ominous mood that one finds in Neel's *Requiem*. The subject matter of Burchfield's work had been stimulated by his reading of Sherwood Anderson's *Winesburg, Ohio*. In that influential model of regionalist literature, the protagonist, George Willard, was inspired to become a writer by the need to connect quotidian small-town life with profound human experience. While walking down an alley off of Winesburg's Main Street, Willard was overcome by "the desire to say words...because they were brave words, full of

Figure 2
The Mysterious Woods 1919
Charles Burchfield
watercolor
14 x 20"
Kennedy Galleries, Inc., New York

meaning. 'Death,' he muttered, 'night, the sea, fear, loneliness.'"[15] Both Burchfield's and Neel's art is informed by the need to speak "brave words, full of meaning," in spite of the risk that they might be nothing *but* words in the unidealized context of daily life.

Despite the traumatic content of the watercolors generated by Santillana's death, Neel's works from these years span a wide range of feeling from sardonically humorous to fancifully imaginative. One of the most unusual is *Harlem River* (1927). This landscape depicts the view from Sedgwick Avenue, which overlooks the Harlem River and the upper end of Manhattan Island, and which would become Neel's home after the birth of her second child, Isabetta, the following year. Urban renewal has now left its legacy of urban blight in the South Bronx, but before the row houses were replaced by high-rise apartments, Sedgwick Avenue was in all likelihood a relatively genteel, reasonably integrated blue-collar neighborhood. At that time, the High Bridge viaduct, which was a short walk from their apartment, brought water to Manhattan from the Croton Reservoir. The Hudson River School poet William Cullen Bryant described the vista in 1874, shortly after the viaduct was constructed.

> At the Harlem River, which forms the northern boundary of the island...the banks of the river are high and well wooded. It is crossed by several bridges, and by a viaduct for the waters of the Croton....It is a handsome structure...of high granite piers and graceful arches, and shows from different points of view, through vistas of trees...with singular and even lofty beauty.[16]

On the Manhattan end of High Bridge is a water tower in the form of a minaret, which in combination with the dome of a Greek Orthodox church a short way upstream must have suggested the Near East to Neel, for she recorded this view less in terms of Bryant's Picturesque than as a scene from *Arabian Nights*. The dramatic sky, with its mystically radiating moon, looks forward to Neel's sublime landscapes of the 1940s to the 1960s, but the fairy-tale quality of *Harlem River* is rarely seen in her work again.

In *Classic Fronts*, painted at Sedgwick Avenue several years later in 1930, the fairy tale comes to an abrupt end. In this seminal work, Neel establishes the compositional motif which will structure her cityscapes for the next half century: the two-dimensional form of the building facade is held in tension with the flat surface of the canvas. In *Classic Fronts*, the side of the building is blank, suggesting – as in the contemporaneous photography of Walker Evans – the hypocritical "propriety" of the false front in American architecture. A single Doric portico unites the two brick row houses, but above the white columns a dark vertical shadow splits apart the otherwise similar structures, disrupting the sense

of quiet produced by the symmetry and simplicity of the pictorial elements. On the back of a photograph of this painting, Neel noted that it was "done after Carlos Enriquez left for Havana, Cuba in 1930." The two central verticals, column and shadow, cause an internal contradiction within the image of the row house (is it attached or splitting apart?), translating the composition into a visual metaphor for the rending of the marriage.

The style and subject matter of *Classic Fronts* derive from the Ashcan School of realism, from tenement scenes by artists such as Robert Henri, John Sloan, and George Luks, who had arrived in New York from Philadelphia during the first decade of the century. Neel has mentioned admiring in particular Sloan's cityscapes, "before he was ruined by Renoir." She was probably introduced to Henri's art while studying at the Philadelphia School of Design for Women, as he had taught there at the turn of the century, and when Neel entered the school some twenty years later, her illustration instructor was a student of Henri's most well-known pupil, George Bellows. Yet, by the 1920s, the urban realism of the Ashcan School had been eclipsed by the more stylistically radical modernists of the Stieglitz circle, and those artists who continued the realist tradition, most notably Charles Burchfield and Edward Hopper, had little interest in depicting the urban populace. Instead, they used anonymous domestic architecture as a vehicle for mood. Neel formulated her style during this "transitional" episode of "expressionist-realism" in American art during the twenties.[17]

After 1930, Edward Hopper probably provided the strongest model for Neel's cityscapes. She may have seen his work when it was exhibited at the Pennsylvania Academy of Fine Arts in 1924, while Neel was still studying in that city, or in 1927–28, when he exhibited at the Frank Rehn Gallery in New York. *Classic Fronts* was completed in the same year as one of Hopper's most well-known works, *Early Sunday Morning* (fig. 3), a painting Neel particularly admired.[18] Although it is unlikely that she saw it before it was exhibited in the first Whitney Annual of 1933, *Early Sunday Morning* exemplifies the desolate cityscapes Hopper had introduced in the mid-1920s. In *Classic Fronts*, the young Neel adopts for the first time Hopper's compositional device of spreading the flat facade laterally across the picture plane and illuminating it by a raking light which both emphasizes the abstract play of form and creates a sense of drama. Neel's work, cruder and more spontaneous, is animated by a nervous energy in the linear rhythms of the fence and balustrades not found in Hopper's considered planes of flat color; nonetheless, they both share those themes given literary articulation by Sherwood Anderson, in particular, that of loneliness.

Figure 3
Early Sunday Morning 1930
Edward Hopper
oil on canvas
35 x 60"
Whitney Museum of American Art,
New York

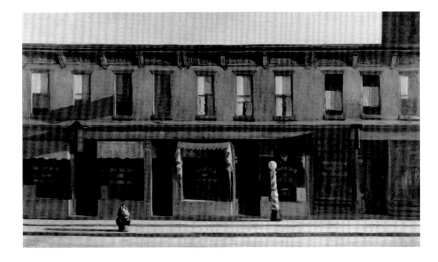

During the period of the breakdown which Neel suffered in 1931, she wrote despairingly of her early creative efforts.

> *...all the little threads of my heart and spirit were*
> *somehow connecting themselves with the classic beauty of*
> *washington bridge.*
> *...and the sad grey wood houses of sedgwick avenue*
> *some red brick ones with classic fronts*
> *I know these are all subjects – paintings with a story*
> *but does it make any difference what sets you into action*
> *...i've lost my child my love my life and all the god damn business*
> *that makes life worth living.*[19]

Fortunately, "the great renunciation," as she titled the poem, took place only on paper, and by 1932 Neel had renewed the connecting threads between her spirit and that of New York City.

THE CITY DWELLING, 1930–70

This essay makes frequent use of quotations from twentieth-century literature to provide thematic parallels to Alice Neel's work. Despite the fact that Neel read widely, the literary references are not meant to suggest that she was influenced by these writers – a fuller discussion of her literary and intellectual milieu awaits a larger study – but to propose that the interpretation of a given artwork can frequently be given greater substance by an analogy to literature. The literary analogies are thought of as a web or net which can catch in its grid the intersections of Neel's paintings with the structure of modernist thought. Neel herself constantly used literary references and metaphorical language in discussing her work. Even if the historian cannot "get back" to whatever analogy or metaphor may have been in Neel's mind while painting, her individual compositions call forth a metaphorical reading bolstered by

literary analogy. The very definition of metaphor has been strongly debated over the last decade and, admittedly, my use of it as an interpretative tool blithely ignores the difficult problems it creates.[20] I hope to circumvent some of the difficulties by using Neel's non-portrait oeuvre as a context against which to check individual readings and ultimately to gain insight into how Neel's work mutters "death, night, the sea, fear, loneliness."

Recent writing on metaphor suggests that it is not simply a vague figure of speech, but is central to all thinking. In *Metaphors We Live By* (1980), the linguistic philosophers George Lakoff and Mark Johnson argue that the mind operates metaphorically, and that the metaphors we use to discuss concepts do not simply elaborate but actually construct their meaning. "If we are right in suggesting that our conceptual system is largely metaphorical, then the way we think, what we experience, and what we do every day is very much a matter of metaphor."[21] In general, important concepts which are difficult to define clearly – love, time, understanding – are structured metaphorically in terms of "natural" experiences – physical orientation, objects, seeing.[22] The authors identify three kinds of metaphors: the first are structural metaphors, in which one concept is structured in terms of another ("argument is war"). The second are orientational metaphors, in which our bodies' physical orientation to the environment organizes a system of concepts with respect to one another; for example, happy/healthy/conscious is thought of as "up," whereas sad/sick/unconscious is "down." The third type are ontological metaphors, "ways of viewing events, activities, emotions, ideas, etc., as entities and substances."[23] Just as human beings are "discrete entities bounded by a surface," the authors argue, so we "...conceptualize our visual field as a container and conceptualize what we see as being inside it."[24] If paintings can be considered objects which stimulate thought, then Neel's paintings can be interpreted in terms of structural, ontological, and orientational metaphors.

It is important to distinguish metaphor from traditional iconography. Although Neel makes use of conventional symbolism, for instance the skull, her pictures are dependent for their meaning not on individual symbols but on the composition as a whole. In other words, the meanings are connoted rather than denoted. The art historian Norman Bryson has argued that the more pictures move away from codified imagery, from denotation, the greater the effect of realism. His chapter "The Image from Within and Without" in *Vision and Painting* argues that "realism" is no less coded than non-representational art, and therefore must be interpreted in terms of conventional, if unarticulated, connotational codes.

Figure 4
Backyards: Greenwich Village 1914
John Sloan
oil on canvas
26 x 32"
Whitney Museum of American Art,
New York

Not only, if at all, in the journey away from denotation does the image acquire its lifelikeness; but in the journey of the codes of connotation away from situation and into an image where, stripped of the delimited significance embodied in actuality, the actions of the codes become diffuse, generalised, potentially but no longer instantially meaningful. Contemplating these despecified, evacuated forms, it is for the viewer to construct and to improvise the forms into signification, through the competence he has acquired from his own experience of the tacit operations of the connotational codes....[25]

In her non-portrait work, Neel always depicted her neighborhood or the objects in her apartment; however, she consistently takes the subject matter "away from situation:" in other words, the residents and their daily activities are rarely included. Because the buildings, landscape elements, and objects are isolated and "despecified," the viewer makes meaning from the relationships among individual elements in the composition.

Before systematically analyzing her use of these motifs, an early cityscape, *Snow on Cornelia Street* (1933), will serve to demonstrate my use of metaphorical interpretation. Each viewer is likely to interpret a given work differently but, because most viewers share the same culture, they have internalized the connoted meanings of certain colors, textures, and gestures, even though there is no dictionary s/he can consult to confirm them. Therefore, through the exercise of what Bryson calls "practical consciousness," the viewer arrives at a condensed reading

akin to a proverb.[26] The truth of one proverb need not necessarily contradict another nor require reconciliation, even though in different contexts one reading may be more convincing than another.

Snow on Cornelia Street provides an early example of a motif which will recur throughout Neel's career: tenement buildings covered in snow. Inclement urban weather – snow, ice, and fog – were subjects favored by Henri and Sloan, and continued by Burchfield and Hopper. Neel's painting, then, finds its precedent in such works as Sloan's *Backyards: Greenwich Village* (1914, fig. 4). In a typically charming scene, Sloan uses the white fields of snow atop the tenements as a stage set for a convivial tale of city life, in which children and animals cavort in their own rooftop world. In *Snow on Cornelia Street*, Neel avoids Ashcan School anecdote, presenting a view which in its initial severity is closer in feeling to the naturalist writer and fellow Greenwich Village denizen Theodore Dreiser than to the sentimental art of Sloan.

> *Once the bright days of summer pass by, a city takes on that sombre garb of grey, wrapt in which it goes about its labours during the long winter...how firmly the chill hand of winter lays upon the heart; how dispiriting are the days during which the sun withholds a portion of our allowance of light and warmth.*[27]

Yet Neel's own story about the painting is more analogous to the joyous mood of Sloan rather than the depressed tone of Dreiser.

> *...at the end of 1933, I got on the PWAP [Public Works of Art Project]. I received a letter to come down to the Whitney Museum, and there I was interviewed by a very nice young man who said: 'How would you like to receive $30 a week for painting pictures.' 'Oh,' I said, 'I'd love it.' And I came home and I felt so happy that I painted* Snow on Cornelia Street.[28]

Happiness as a snow-filled tenement courtyard in winter? Can what we see, and the interpretation we initially make, be in any way reconciled with Neel's words? The answer is no, because an artist's work and her verbal statements about it never carry the same meaning, but the contradiction can be at least partially resolved by the conclusions drawn from a second comparison with Edward Hopper. In his *Manhattan Bridge Loop* (1928, fig. 5), the elongated, horizontal format provides a panoramic vista, but the span of the 'el' across the width of the canvas visually cuts the viewer off from access to the cityscape. Neel's bleak courtyard, on the other hand, is organized by a series of regulated spatial registers which permit the viewer to connect with and mentally wander through the space. Hopper remains physically and emotionally distanced from his site, whereas Neel visually inhabits her milieu. Neel includes multiple landing platforms – ledges, rooftops, fire escapes, all

Figure 5
Manhattan Bridge Loop 1928
Edward Hopper
oil on canvas
35 x 60"
Addison Gallery of American Art,
Phillips Academy, Andover

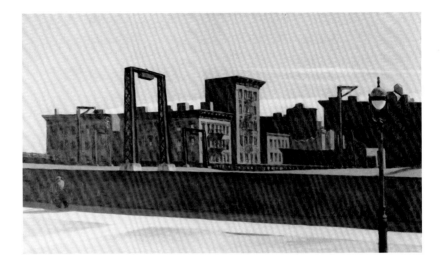

manageable transitions between levels – within a clearly circumscribed area. In Hopper's more monumental and disturbing vista, on the other hand, the space is limitless and disjunctive. Hopper depicts a city with which no inhabitant can connect; Neel paints her own front yard. The painting has the intimacy of *Classic Fronts*, but instead of the central shadow which splits apart the houses in the earlier work, Neel joins the foreground and background planes with an uninterrupted line which elides the vertical and horizontal dimensions, serving as both the side of a neighboring apartment house and the top of the fence behind it.[29] The repeated geometric elements serve as signs referring to metaphorical concepts: a safe enclosure with a soft "bed" of snow and with an accessible, if narrow, way out.

The tenement alleys and courtyards in early twentieth-century American art are generally crowded with human activity, whether vivacious, as in the work of Sloan and Bellows, or sinister, as in the documentary photographs of Jacob Riis, or both, as in the writing of Neel's friend, the Communist Mike Gold: "Excitement, dirt, fighting, chaos! The sound of my street lifted like the blast of a great carnival or catastrophe...."[30] During the Depression, obviously, more negative moods predominated, and artists frequently depicted the city's back spaces as filled with the dejected forms of the poor and homeless.[31] Neel's early cityscapes fit none of these formulae. In *Snow* (1933), a snow-covered alley off Cornelia Street dead-ends at a fence. Schematically rendered clothes and implements imply that this is home to someone, but Neel avoids sentimentalizing the poor, while nonetheless registering the severe hardship of the Depression, by tactfully omitting the alley's occupant. It is to her credit that Neel never makes the viewer a voyeur: she does not record people unawares, or peer through open windows at unsuspecting occupants, as did both Hopper and Sloan. Neel avoids the pitfall Allen Sekula has identified as the modern artist's propensity for "slumming," which promotes an "ideology of separation" and

"induces the intellectual worker to view the 'working class' with superiority, cynicism, contempt, and glimmers of fear."[32] Instead, she observes her neighborhood, but refrains from stereotypical depictions of her neighbors.

Thus, although Neel shares her subjects and symbolism with other major American artists, her use of metaphor is peculiarly her own. The following are the repeated elements in the cityscapes from which Neel consistently elaborates her metaphors: **1** the vertical orientation of the canvas, which functions as an orientational metaphor; **2** the flat, frontally-oriented apartment facade, which serves as an ontological metaphor; **3** temporal elements, effects of light and weather, which can be defined, albeit imprecisely, as structural metaphors (i.e., "shadows are death").

The vertical orientation of the canvas is at one level literal and obvious: after all, New York is a vertical city. However, verticality provides Neel with two metaphors, the first of which is that of a window, through which one sees across a street or courtyard to an opposite wall. By for the most part implying rather than including the window which framed her view, that is, by making the four sides of the painting itself metaphorically the window, Neel avoids the amateur theatrics of the Ashcan School. Instead of narrative, we are given a scene as an object, as an entity present to us rather than a stage for imagined human actions. When the window is not implied as frame but depicted as the constituent element of a building facade, each refers to a life lived "inside" it, one which can never be known. Through the device of the painting/object, window and facade – outside and inside – meet on a single plane.

A second consequence of the vertical orientation is that by echoing the standing position of the body, the facades (or, in the landscapes, trees) are anthropomorphized. The anthropomorphic effect of verticality of these "orientational" metaphors can be felt by again comparing Neel's *Snow, Cornelia Street* to Hopper's *Manhattan Bridge Loop*. In a letter to the director of the Addison Gallery of American Art, Hopper stated, "I spend...a long time on the proportions of the canvas, so that it will do for the design, as nearly as possible what I wish to do. The very long horizontal shape of this picture, 'Manhattan Bridge Loop,' is an effort to give a sensation of great lateral extent...to make one conscious of the spaces and elements beyond the limit of the scene itself."[33] Hopper has consciously chosen to create a space whose extent cannot be measured, thereby assuring the alienation of the viewer from the scene; this orientation contributes to the "lifelessness" of his depopulated views, and thus to their depressed mood. The verticality of Neel's cityscapes, on the other hand, compresses the space so that it conveys the energy and vitality of urban life despite the fact that her views are initially as stark and impassive as Hopper's.

Contemporary realism has followed Hopper's example rather than Neel's. In her discussion of realist cityscapes, the art historian Linda Nochlin argues, "In the work of the new realists, the mystery of the great city and even its peculiarly modern dimension of the heroic are subverted...by a kind of overdetermination: [either] too close an angle of vision...or unaccustomedly wide. In such cases the spectator is unable to orient himself either visually or emotionally to the space presented so meticulously by the painter."[34] Neel's cityscapes, and her landscapes as well, rigorously maintain a human orientation and scale. Unlike the contemporary realists Nochlin referred to – Rackstraw Downes, Richard Estes, Catherine Murphy – Neel insists on connections. In *Snow* (1967), a painting of Strauss Park, the branches of the leafless tree outside Neel's window seem to reach with all the kinetic energy of Rodin's drawings of Cambodian dancers for the linear tracery of the park's ginkgo trees, so that even under the constriction of the snow, the paint seems to rise through the vertically multiplying elements like blood through capillaries. Life, in muted form, continues even in the dead of winter.

The metaphorical structure of Neel's work distances it from realism as defined by art historians, if not from Bryson's theoretical analysis of the term. For instance, Nochlin has argued that in realist art,

> *...details are related in terms of metonymy, that linking of the elements of a work of art through contiguity which the linguist Roman Jakobson has posited as the fundamental structure of realist art, opposing it to the domination of metaphor in romantic and symbolic works.*[35]

Neel rejected the philosophical implications of metonymy which now dominate much of realist art. In identifying the artists she most respected, Neel cited Goya, Munch, and Kokoschka, adding, "I do not like the new realism – facts just plain facts. I mean a table, a chair, a human, and a room – compositionally they're the same thing. But they're not the same thing. Not to me anyway."[36] Neel deliberately avoids "realist objectivity," the location of meaning within the mute objects in a painting and an obstinate refusal of metaphor. For the viewer of Neel's work, her use of orientation, detail, and light inexorably bring metaphorical meanings to mind.

If the vertical orientation of her canvases permits Neel to create metaphors for the connections between the animate and inanimate, body and building, the flat facades which both constitute and parallel the picture plane can be manipulated to suggest a greater or lesser distance from front to back, which in turn creates metaphors for spiritual "freedom." In both *Fire Escape* (1946) and *Rag in Window* (1959), the space is tightly compressed and "claustrophobic." In the former, the repeated

vertical, horizontal, and diagonal black bars which construct the fire escape, each with its taut stripe of white snow, so emphatically underline the feeling of confinement that the metaphor "like a prison" comes immediately to mind. The compositional tensions created by the painting's stark linear oppositions also presages Franz Kline's Abstract Expressionist works. As she told Henry Geldzahler in her last interview: "Do you know when I painted 'Fire Escape?' 1946. And do you know what that painting shows? That realism can be as good as abstraction."[37]

Fire Escape does demonstrate the similarities in form and content of the supposed antipodes of abstract and realist art in this period. In the decade after the war, the spontaneous mark on the canvas itself, sometimes tentative, sometimes strident, was a metaphor for the artists' paradoxical emotional (dis)position between despair over the past and insecurity about the future. If *Fire Escape* presages expressionist abstraction in this respect, *Window at Night* (1958) reflects the influence of the mystical paintings of Clyfford Still, the one Abstract Expressionist artist she admitted to liking. Yet her paintings do not attempt Still's "heroic" scale. Neel's cityscapes from the 1940s and 1950s are diminutive, as modest as the architecture of Spanish Harlem.

In *Rag in Window*, also from 1958, the space is more ambiguous; it is not clear on which plane the elements sit. The schematic green lines, which suggest window mullions as seen by the indistinct resolution of near vision, seem to jump between the front and back planes. The symmetry of the composition is so severe that this work is at the same time the most spatially ambiguous and the flattest of the series. Painted on an irregularly shaped board, perhaps the bottom of a drawer, this terse, seemingly offhand work calls forth elaborate interpretation. The spattered, stained surface, at once atmosphere and painterly automatism, and the monotonous, leaden 2/2 rhythm of the four windows seem a visual counterpart to Beckett's prose from the opening scene of *Endgame* (which was written one year before the painting was made): "Grain upon grain, one by one, and one day, suddenly, there's a heap, a little heap, the impossible heap."[38] In turn, Beckett's description of *Endgame*'s set is a verbal counterpart to the painting: "Bare interior. Grey light. Left and right back, high up, two small windows, curtains drawn."[39] Both writer and artist were obsessed with the seeming inevitability of nuclear destruction, but Neel rejected Beckett's nihilism, since she believed that as a result his writing represented "encapsulated capitalism." Yet their formal means are remarkably similar; in each artist's work, objects and ideas function "on the same plane." Small wonder that Neel gave the pathetic grey cloth which hangs from the right-hand window its own metaphorical moniker, "the twentieth century."

Whatever Neel's stated opinions about Beckett or Still, her cityscapes from the 1940s and 1950s have a metaphorical content similar to that of the dominant literary and visual movements of the post-war era: existentialist drama and Abstract Expressionist painting. Jane Hale's study of Beckett's revolutionary use of dramatic perspective helps to expand the analogy with Beckett, by tracing his use of space and time in *Endgame* to suggest an apocalypse continually in the process of becoming. Life's meaninglessness in the face of inevitable yet unknowable decline is expressed metaphorically by the use of "a great deal of movement...yet nothing and nobody can actually be said ever to get anywhere, except perhaps a bit closer to an end whose very existence is uncertain."[40] This description of the use of movement in *Endgame* provides an apt verbal counterpart to Neel's tattered rag, hanging from the tenement window and endlessly twisting in the wind.

By the early 1960s, when Neel's work finally began to be regularly exhibited and reviewed, the size of Neel's painting did increase, and with it the implied distance between front and back planes. *Snow* (1964), the last of the series of winter cityscapes which began with *Snow on Cornelia Street,* is roughly "window" size (47 x 26"), so that the sides of the buildings in the alley behind Neel's new home at 300 West 107th Street serve as shutters pushing into the space, which then drops vertiginously to the back wall. The visual footholds of the perspectively skewed windows are more precarious here than in the 1933 painting; only the single window at "eye" level in the otherwise blank wall at the end of the alley provides a stable resting point. Metaphorically, there is less "support" in the visual elements here; the individual is on her/his own, but "stable," "in place."

Snow exemplifies as well the third metaphorical element in Neel's cityscapes: architectural detail. They are features, individual traits of the species "tenement." The linear trails of the fire escapes, the varying patterns and color of the blank panes of the windows lend a varying character to each building, and a physiognomy as telling as those of Neel's portraits. It is for this reason that figures in the windows would have been inappropriate and redundant.

The metaphorical use of detail also informs the landscapes. Two nocturnal seascapes painted in 1947, within a year after the death of Neel's father, serve, as did *Requiem*, as a meditation on loss. Both *The Sea* and *Cutglass Sea* were painted from memory after she had walked down to the ocean from the family's summer house at Spring Lake, New Jersey. In *Cutglass Sea*, the finger-like shadow – "the hand of death" – grips the shore, while the black cloud serves as a pair of pincers to pluck the moon/soul from the sky. In *The Sea*, detail disintegrates to gesture, but still operates metaphorically even when its referent is not immediately obvious. For example, the black clouds which snake ominously through

the sky and across the water are obvious symbols of death, but the large "X" under the moon, which seems to have appeared automatically through the force of the brushstrokes, reads immediately as erasure. The humped horizon line increases the instability of the agitated cloud formations in the night sky, the compositional turmoil contrasting with the eerie calm of *Cutglass Sea*. The two seascapes thus project the two extremes of feeling – melancholy and anger – characteristic of the grieving process, while their mutual starkness reflects those feelings' common source in loss.

The fourth compositional element, light, whether in reflected shadows or in the depiction of sky, is, as one would expect, an emphatic metaphor for mood. In general, Neel shows a preference for overcast days, so that the light is even and cast shadow functions to outline shape and emphasize abstract structure. On the other hand, the snow and cast shadows are also used as an organic counterpoint to the geometry of architecture and barren landscapes, rendering them less rigid. The play between hard and soft sets up one kind of metaphorical opposition, whereas the light/dark oppositions set up another.

Neel's most dramatic use of light is in *Sunset in Spanish Harlem*, from the productive year 1958. On the steel grey surfaces of the buildings she viewed across the street from her second-floor apartment on 108th Street, Neel has brushed strips of crimson and coral, siphoning off the ravishing warm colors from the sky, thereby metamorphosing the drab tenement surfaces into abstract paintings and the clouds into dance. The unusually sprightly windows seem almost "tickled" by the cosmetic coloring, which is at once both paint and light. To be painted by the sky: the feeling is euphoric.

Neel's precise registration of the particular colors of urban sunsets, a transference of the careful observation of rural nature, as established by the artists of the Hudson River School in the nineteenth century, to city nature, recalls as well the simultaneously ironic, ecstatic, and apocalyptic tone of the words of *New York Times* drama critic Brooks Atkinson. In an article from 1951 entitled "Savage Sunsets," he "explained" to the reader the reason for the "transcendent splendor" of New York's sunsets.

> There is a commonplace practical reason for their barbaric magnificence. The industrial plants, railroad locomotives and steamships of New Jersey send up a thick cloud of sullen smoke that rolls across the Palisades, showers us with specks of grit and soot, and breaks up the light. The blue rays, which have a short wave length, are widely scattered. But the red rays, which have long wave lengths, pierce the barrier of smoke and come through to us....Our sunsets are, therefore, abnormally red. Our days end violently....[41]

The primitive buildings in Spanish Harlem have reacted to the sky's barbaric display with a dance of celebration.

Although such depictions of the apocalyptic merging of culture with nature seems to confirm Nochlin's association of metaphor with romantic art, social content is nonetheless never absent in Neel's cityscapes. In fact, Neel's "Beckett-like" Spanish Harlem works contain sufficient evidence of the experience of tenement living to prompt some editorializing. Neel did not travel daily to a studio to paint; she never distanced herself from her domestic surroundings in order to "create." Neel painted what, where, and how she lived, an approach unique in American art. Although her cityscapes do not provide a document of the changing face of New York City, they do demonstrate that for the poor the experience of the city remained essentially the same throughout the century.

The "railroad" apartments she lived in in Spanish Harlem were built in the last two decades of the nineteenth century to help alleviate the inhuman living conditions of the slums, but instead they merely perpetuated the problem. Initially designed in 1879 to provide better ventilation and light though a central air shaft, the railroad apartment's layout, one-room-wide and lacking a hallway, a scheme which was created to maximize rentable space, meant that the interiors were as dark and airless as their predecessors.[42]

However cramped and dark the apartment at East 108th Street, Neel had no particular aspirations to move to better quarters; rather, she was forced to move because of a landlord's tactic which is as commonplace now as then: he simply refused to maintain it, thereby forcing the tenants out and leaving him free to raise the rents for the next victims.[43] Within the restricted area of Manhattan Island, the boundaries of slum districts have shifted over half a century, but the problem of decent, affordable housing has never been solved. Neel's tenement facades reflect the feeling of living in a home choked both financially and spatially. The large-scale commercial developments of late capitalism have only aggravated the problem, as the urban semiologist Raymond Ledrut has pointed out in his essay, "Speech and the Silence of the City."

> *The great capital or the State reveal themselves in glass and steel, verticality and right angles adapted to the spirit of the office, the world of business or administration, which asserts itself thus as a power transcending the life of the citizens. Historical action eludes cities and their inhabitants. It is concentrated in high places, in a sphere of social space supreme and detached from local life. Its symbolism is that of deprivation and alienation.*[44]

Neel refused to acknowledge such a social space in her art, concentrating instead on the great social "body" living closer to the ground. Her maps of the mental geography of tenement life are thus particularly pertinent today as icons of civic indifference.

THE LATER CITYSCAPES

After her move to the West Side in 1962, Neel's cityscapes become less strictly metaphorical and increasingly more narrative, as they begin to open either to the sky or to the street. As a result, the "social context" is literally rather than metaphorically depicted, although in strictly limited terms. The paintings done in the corner room overlooking Broadway include pedestrian and vehicular traffic for the first time since the 1930s, but neither is ever more than schematically rendered. *Cityscape* and *Rain*, both from 1968, depict Broadway in inclement weather, but unlike the Harlem cityscapes they record the ongoing activity of street life.

In *The Death and Life of the Great American Cities* (1961), the sociologist Jane Jacobs observed that at this time the neighborhood around Neel's apartment at the corner of 107th and Broadway was an almost exaggerated example of the kind of diversity of architectural functions and populations she found necessary to the health of the city.

> *People's love of watching activity and other people is constantly evident in cities everywhere. This trait reaches an almost ludicrous extreme on upper Broadway in New York, where the street is divided by a narrow central mall, right in the middle of traffic...on any day when the weather is even barely tolerable these benches are filled with people at block after block....Eventually Broadway reaches Columbia University and Barnard College....Here all is obvious order and quiet. No more stores, no more activity generated by the stores, almost no more pedestrians crossing – and no more watchers.*[45]

For Jacobs, it is the "watchers," both on the streets and in their apartments, who keep the city safe, and her dislike of high-rise "urban renewal" apartment blocks was due to their inaccessibility to the street, and the resulting vulnerability of the pedestrian.

Neel may have been unaware of Jacob's thesis that the safety of the sidewalks – secured not by the law but by the inhabitants, that is, the shopkeepers and apartment dwellers – is the key to a habitable city; nonetheless, in the 1960s her attention is less drawn to the apartment's facade as a psychological portrait of urban domestic life than to the sense of community which can arise on the street, even when the community consists not of friends, but of familiar faces within the passing crowd. In an interview from 1980, Neel described herself as a watcher, in comparable if somewhat more jaded terms than Jacobs.

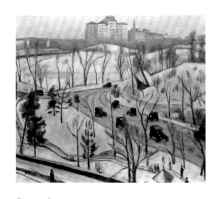

Figure 6
Winter, Central Park 1918
Samuel Halpert
oil on canvas
25 x 30"
Kennedy Galleries, Inc., New York

I really live out my front room windows, which face up Broadway from 107th Street. It's like having a street in your living room....Since I've always been claustrophobic, it is a great escape for me not to feel shut up in a room....From my West End Avenue window I can see Strauss Park, shaped like a violin with a fountain, and ginkgo trees. There is one man, a bum, who is there every morning....Then he goes and sits on a stone bench on the Broadway center strip and nurses [his beer] the way the rest of us nurse our breakfast coffee....The center strip is like his living room.[46]

If the Spanish Harlem cityscapes spoke of claustrophobia and isolation, the upper West Side cityscapes return to the slice-of-life scenes of the Ashcan School, particularly the charming veduta of a later practitioner, Samuel Halpert (fig. 6). In Halpert's *Winter, Central Park*, 1918, space is also tilted so that it includes the street, with toy-like vehicles and the occasional pedestrian provided with room to maneuver. Neel's *Cityscape* space is more dynamic; spilling forward toward the front plane, it creates both a sense of energy and of intimacy. The world was indeed coming to her door at this point, as her career was gaining a momentum which would reach a frenetic level by the mid-1970s.

The increased space in her cityscapes, which permits a greater connection with the social life of the city, curiously corresponds to an increasingly pantheistic approach to her landscapes. *Sunset, Riverside Drive* from 1957 marks the transition from the expressionist seascapes of the 1940s to to the ecstatic experience of *Eclipse* (1964). Neither provides a reference to their urban sites; nature no longer produces its spectacular effects in tandem with culture, as it did in *Sunset in Spanish Harlem,* and instead becomes a direct source of the Sublime. Like so many American twentieth-century landscape painters – Marsden Hartley, Arthur Dove, Milton Avery – Neel here equates nature with spiritual experience. However, it is important to remember that Neel saw the eclipse out the same window from which she observed the derelict nursing his beer. *Cityscape* and *Eclipse* represent the poles of urban experience, but are complementary rather than opposed.

During the 1970s, Neel began to spend her summers at the home of her son Hartley and his wife Ginny in the rural resort town of Stowe, Vermont. There nature lost its mystical aura. A good decade before cows became trendy, Neel captured the combination of stupidity and charm which makes this source of milk products a delight to watch as well as the subject of innumerable kitsch items. Her *Cows, Vermont* leaves one with the impression that by 1971 Neel found the idea of the bucolic a somewhat silly anachronism. But it is perhaps more important that Neel's attitude toward her art is sufficiently unpretentious that she can

let wit and humor, that rarest of commodities in the "High Art" of painting, have free play.

At this time, she painted the view across 107th Street of the neighboring apartment complex with its corner store. In *107th and Broadway* (1976), the curved shadow of Neel's apartment house half envelops the facade, and reduces the windows beneath it to insubstantial blurs. Time enters Neel's later cityscapes in as restricted a way as space, however. Because time's movement is alluded to by the use of static shape rather than by the illusion of atmosphere, Neel continues to hold narrative, with its inevitable closure (death) at bay. The dark shape forms a vaguely yin/yang pattern with the white facade, and life and death, the one inseparable from the other, are kept in balance. "That was Death, of course, creeping over here,"[47] Neel commented, and the painting does embody her belief that "every person is a new universe unique with its own laws emphasizing some belief or phase of life immersed in time and rapidly passing by. Death, the great void of life, hangs over everyone."[48]

INTERIORS: STILL LIFES AND FLOWERS

Neel's still lifes have the ascetic quality of her exteriors, and therefore lack the sensuality and glorification of abundance which are frequent characteristics of the still-life genre. No panoramic vistas on the exterior; no lavish displays of abundance on the interior. Instead, Neel continues the art historical legacy of the American still-life artists whom art historian William Gerdts has called "painters of the humble truth."[49] Instead of lavish displays designed to impress the viewer with the wealth of its owner, humble still-life painters choose to record the significance which utilitarian objects gain through continuous human use – in the words of Alice Walker, "the everyday me." In his comprehensive study of still life, Charles Sterling concluded that still lifes hold our interest "because inanimate things, so closely bound up with daily life, represent man's most immediate commerce with matter. They afforded each of us – when we were babes in the cradle, toying with objects for hours – our first contact with the world...."[50]

Like the cityscapes, the still lifes are depopulated, and so the objects depicted both "stand in" for family and friends and speak to their absence. Although still life is inherently paradoxical, both a celebration of everyday life and an acknowledgment of its passing, Neel's still lifes present death and life as coextensive rather than in conflict. The artist May Stevens, the first person to write on Neel's non-portrait work, has expressed this point eloquently: "The paintings painted when no one is there to sit for her show us what she sees when she is a woman alone by the windows, by the sink, or by the dining-room table with its empty drawn-up chairs, feeling the life in the inanimate world and the death that comes close in the pain of absence."[51]

The majority of Neel's still lifes are in the "table-top" format, and continue the post-impressionist device of angling the table's surface so that it forms a flat plane in tension with the front plane of the canvas. Within this familiar format, Neel created at the beginning of her career one of the most mesmerizing still lifes in American art, *Symbols (Doll and Apple)* (1932). One of her most resolutely frontal and symmetrical works, *Symbols* is clearly meant to portray an altar. However, the objects she places on the altar do not have the specific religious denotation of the palm fronds and cross on the back wall. Nor are the rag doll, red rubber glove, or green apples objects that are found on the home shrines assembled by the devotees of the African/Catholic cult Santeria, which Carlos' sisters, who raised Isabetta, assembled in their home in Cuba.[52] This is a private altar, whose meaning Neel described as follows:

> I painted Symbols *in 1932. A short time before, Roger Fry had written a book where he gave Cezanne's apples the same importance in art as the religious madonnas. The doll is a symbol of woman. The doctor's glove suggests childbirth. The white table looks like an operating table. And there's religion in this, with the cross and palms....This wretched little stuffed doll with the apple, and you see we're still a stuffed doll. Look what's happening to us. Do you think we want to die of a nuclear thing?"*[53]

Neel's breathtaking leap from formalist art criticism to the nuclear holocaust is a bit too incoherent to be of use in decoding this work, but the references to childbirth do provide useful anchors for speculation. By 1932, Neel had had two daughters, one of whom had died, the other of whom was being raised outside the country by her sisters-in-law. She had just moved back to New York after recovering from a nervous breakdown and attempted suicide, and as she told Professor Hills: "You see, I always had this awful dichotomy. I loved Isabetta, of course I did. But I wanted to paint. Also, a terrible rivalry sprang up between Carlos and me."[54]

Symbols may well refer to the "awful dichotomy" Neel faced as an artist and a mother, for it is sufficiently ambiguous to allow for two different readings. The doll has Alice's and Isabetta's blue eyes, and could be either one or both of them: that is, both Neel herself (the artist/art) and Isabetta (the child/motherhood) are being sacrificed on this cruel altar, a clinical examining table drenched in a harsh fluorescent light. The apple, normally a sensuous symbol of female fertility, is here obscenely related to Eve's sin by being shoved rudely into the doll's crotch, where it serves as a contraceptive to creativity and/or fecundity. The doll is impaled on an altar to an unresolvable dilemma: motherhood and artistic career.

This startling work is seemingly without precedent in American twentieth-century art. The doll (simultaneously woman and child), the red

rubber glove, and the glaring light suggest familiarity with Giorgio De Chirico's motifs, but given the early date, it is difficult to determine whether the similarity to De Chirico is coincidental or not. The founder of the Scuola Metaphysica had been shown for the first time in New York in the late 1920s at the Kurt Valentin Gallery, and Lloyd Goodrich, Hopper's biographer, reviewed De Chirico's exhibit for *Arts* magazine: "It is largely this trick of grouping incongruous objects...that accounts for the nightmare quality of his work. As in a dream, these juxtapositions have a suggestive and troubling quality...."[55] Moving far beyond her expressionist work of the mid-1920s, Neel's art certainly has the "suggestive and troubling quality" of De Chirico's proto-Surrealist work, but there is no evidence that she had seen or read about his work by this date.

Figure 7
Henry Ford Hospital 1932
Frida Kahlo
oil on metal
12 x 15"
Fundación Dolores Olmedo Patiño,
A.C., México

The similarities with Frida Kahlo's work are even more remarkable. Robert Storr described *Symbols* as "...the sparsest of icons to private female hurt – as intense as a work by Frida Kahlo...."[56] In 1932, Kahlo was in the United States with her husband Diego Rivera, who had been granted the second one-person exhibition at the Museum of Modern Art during the previous winter. In the spring, the couple went to Detroit, where Diego began work on a mural celebrating the American automobile industry. There, on July 4, Frida endured a traumatic miscarriage.[57] Kahlo, like Neel, was at the beginning of her career at this point, and paintings such as *Henry Ford Hospital* (1932, fig. 7), which memorialize this event, graphically portray the physical and psychological aspects of her pain. As with Neel's work, pain specific to women is displayed within a masculine, clinical environment which serves as a morbid contemporary altar. The source in Mexican folk art is more directly traceable here than is Neel's in Cuban altars, for Kahlo's painting is done on sheet metal in order to imitate retablos, the painted religious offerings made by a person who has survived a disaster. Kahlo does not depict specific saints or religious symbols any more than Neel did, but as her biographer Hayden Herrera has pointed out in a description which also fits *Symbols:* "As in retablos, the drawing is naively painstaking, the color choices are odd, the perspective is awkward, space is reduced to a rudimentary stage, and action is condensed into highlights."[58]

Rivera commented that "Frida's retablos do not look like retablos, or like anyone or anything else...[for] she paints at the same time the exterior and interior of herself and of the world."[59] But they *do* look like someone else, the then unknown Alice Neel, who also simultaneously explored the exteriors and interiors of her life. Both were Marxists, both were political activists, and both, for reasons as yet unexplored, decided independently of each other to entirely rethink the way the naked female body was depicted in Western art. From about 1930 on, both women present physically and directly what previously had only been

portrayed euphemistically and indirectly: pregnancy and its discomforts, childbirth and its trauma, inventing a new genre – the portrait-still life – to do so. Because the enormous influence of Latin American art on North American art during the years between the wars is just beginning to be explored, there is really no way at present to account for the remarkable parallels between these two artists, but one can argue that the overtly female content in both artists' works prevented their receiving more than limited recognition before the 1970s.

Symbols literally sets the stage for Neel's subsequent interiors; in a far more explicit way than the cityscapes, and perhaps even the landscapes, they speak directly to her relationships with others, by presenting what it means to be "surrounded by the smell of one's own things." (Netsilik Indian). Three works which span her career will serve as examples: *Still Life with Fruit* (1940), *Loneliness* (1970), and *Jar from Samarkand* (1973). *Still Life with Fruit* is a small, dark painting with a barely legible interior space. Within its rectangular armature is an oval bowl containing spherical, generic "fruit." The whole composition is so generalized as to register primarily as contrasts of shape and of light and dark. The fruit "glows" yellow and orange, and yet the light which passes over it leaves it half-bruised by shadow. If the spherical orbs can confidently be said to refer metaphorically to seeing, then the light/dark contrast refers to the sight which is lost with the coming of night. The yin/yang pattern seen in *107th and Broadway* makes its first appearance on the large yellow sphere, but the other objects in the composition, the empty cup, the black shadow of the bowl and the skull-like rag, tip the light/dark balance in favor of the dark, to blindness. Neel described the painting to Hills by quoting Rimbaud.

> *Richard was ill with an eye infection and this bowl of fruit*
> *assumed immense proportions. I think one of Rimbaud's poems*
> *says: 'In certain states of the/spirit which are almost/supernatural,*
> *the/profundity of life is/ revealed in the spectacle, however/*
> *ordinary it may be,/that we may have in/front of our eyes. It/*
> *becomes the symbol of/life.' I think this occurred in my painting*
> *of the wooden bowl with the fruit.*[60]

A number of Neel's works from these years treat the hitherto taboo subject of child abuse, but this oil conveys the very core of the trauma by displaying the preciousness and fragility of the light trapped within the round socket of the "eye."

Loneliness is an exceptionally tall, narrow painting opposing stasis and movement in its upper and lower halves. The composition in the upper half is rigidly geometric, the rectangular window dividing into squares in

order to further subdivide the two windows "outside" on the opposite facade. In contrast to this rigidity and frontality, the old, boxy, oxblood-colored leather chair in the lower half of the canvas slips on the diagonal toward us, unmoored by the amorphous, unstable shadows on the ground plane. Another shadow, ghostly white, passes through the chair's seat to the floor.

May Stevens reports that *Loneliness* "…was painted when Hartley, her younger son, married and left home. This is one of the paintings which means the most to the artist."[61] The stable, upper part of the canvas, with its two identical windows, thus refers metaphorically to Hartley and Ginny, whereas the old (and soon-to be-discarded) unstable chair refers to Neel, who is both "shut out" and "at loose ends" with her son's departure. Neel also told Stevens: "Sometimes I feel awful after I paint. Do you know why? Because I go back to an untenanted house. I leave myself and go out to that person and then when I come back there's a desert."[62] In its metaphor for the loss of self which occurs with the departure of one's child, *Loneliness* presents "that terrible need for contact" which Linda Nochlin found so moving in Katherine Mansfield's *Journal.*[63] Said Alice: "You know what the great thing in the world is? Loneliness."[64]

The objects in *Jar from Samarkand* refer to a friend rather than to family members. Slanting toward us is the smooth brown plane of Neel's kitchen table, fringed with the decorative curves of the wooden chairs. At the front edge of the table sits the world's most unprepossessing piece of pottery, the jar from Samarkand. It has little of the decorative interest, for instance, of the pottery bowls Matisse collected for use in his still lifes, but its image in the painting nonetheless creates a pressure sufficient to cause the table to tilt like a lever. Compositionally, the jar forms an emotional counterweight to the full bowl of fruit anchored at the painting's center.

According to May Stevens, the jar was a gift from a friend, David Gordon, a writer for the *Daily Worker*, who bought it for Neel as a souvenir from his trip to Soviet Asia. Gordon had died shortly after his return, and the gift was delivered to Alice by his wife.[65] In this lively work, however, there is little sense of loss or mourning; primary is Neel's delight in the object (however humble) and in the importance it holds for her. Its presence orders everything around it, permitting greater appreciation of the beauty of the fruit and of the chairs.

The reader will probably be none too surprised to learn that I have found a poem that "matches" this painting. Wallace Stevens' *Anecdote of the Jar*, c. 1923, brilliantly constructs an almost nonsensical poetic image in order to create an exceptionally vivid metaphor.

I placed a jar in Tennessee,
And round it was, upon a hill.
It made the slovenly wilderness
surround that hill.

The wilderness rose up to it,
And sprawled around, no longer wild.
The jar was round upon the ground
And tall and of a port in air.

It took dominion everywhere.
The jar was gray and bare.
It did not give of bird or bush,
Like nothing else in Tennessee. "[66]

Stevens' jar, like Neel's, may be plain and "unaesthetic" but it carries sufficient weight to order all of nature while remaining separate from it. A gloss might read: one need not be pretentious, but only accurate in emphasis to create meaning where previously there was only the chaos of the lived situation. Stevens' language is as direct and stripped as Neel's pictorial means, and his jar and Tennessee woods have the same metaphorical relation to each other as do Neel's jar and fiddleback chairs.

One of Neel's most sensuous still lifes, *Still Life with Black Bottles* (1977), continues this theme. The contrast here of the severe black bottles and the overflowing bowl of fruit suggests a life/death pairing similar to that found in *Jar from Samarkand*, but adding a reference to the familiar "three ages of man" in the bottles themselves, one unopened, one half full, and one empty. The authors of *Art What Thou Eat: Images of Food in American Art* find the same metaphorical means in Neel's earlier *Cut Glass with Fruit* (1952).

> *In this painting, the emptiness of the room is emphasized both by the unoccupied chair pushed under the table and by the stark, relatively large areas of space. An ominous tone is struck by the glittering, sharp, curving edges of the glass bowls seen in opposition to their functions as receptacles of organic flesh. This effect is reinforced by the contrast of the nearly empty bowl on the left to the full bowl on the right....The canvas here is an arena in which the inert objects project their contrasting characteristics.* [67]

Although the still lifes continue the use of ontological metaphor found in her cityscapes, the several interiors discussed above are more directly biographical. With the exception of one or two works on paper, Neel did not paint a self-portrait until 1980, and so the interiors can be said to constitute a self-portrait of her middle years. For instance, *Still Life with*

Decoys is a humorous reference to Alice-the-duck's being followed by two drakes, the two men in her life, Sam Brody and John Rothschild. A more poignant example is *Still Life (White Window)* (1958), in which cups of paint are placed not on a palette, but on a window sill bathed in natural light, creating another altar, this one genuinely reverential, to her art.

The autobiographical content and visual intimacy of these non-figurative "self-portraits" suggest that there may be another aspect of the interiors which requires exploration. Although one can rationalize that Neel's work has been neglected because it appears traditional, her art is far from academic, for her "ideology," to use Lippard's term from the beginning of this essay, is genuinely radical. Neel's interiors arguably present a specifically female point of view, projecting values that reflect a woman's social conditioning and which might therefore have been received by the male dominated art world as trivial, inscrutable, or irrelevant.

Although Neel was championed by the women's movement, and welcomed its help and support, her attitude toward it was equivocal. She had liberated herself from conventional expectations about women early on, and having struggled alone for so long, she was not particularly interested in becoming a "joiner" in the 1970s. But in 1971 she did affirm her belief in a female "voice."

> *The women's lib movement is giving the women the right to openly practice what I had to do in an underground way. I have always believed that women should resent and refuse to accept all the gratuitous insults that men impose upon them....I read a quote by Simone de Beauvoir saying that no woman had ever had a world view because she had always lived in a man's world. For me this was not true....No matter what the rules are, when one is painting, one creates one's own world.*[68]

Feminist scholars have been wrestling with the issue of the female voice since the 1970s, but unfortunately such arguments are now at an impasse.[69] Having by the early 1980s rejected "essentialist" arguments because they merely perpetuated cultural stereotypes, scholars have found it difficult to pin down precisely how the woman artist manages to go beyond either reflecting cultural conditioning or providing a critique of it. Of these authors, Griselda Pollock in her essay "Modernity and the Spaces of Feminity" has attacked this question head-on and through her efforts has provided a useful model for interpreting Neel's art. In her comparison of Berthe Morisot's and Mary Cassatt's constricted interiors (fig. 8) with the dynamic urban exteriors of flaneurs such as Degas and Manet, Pollock asks:

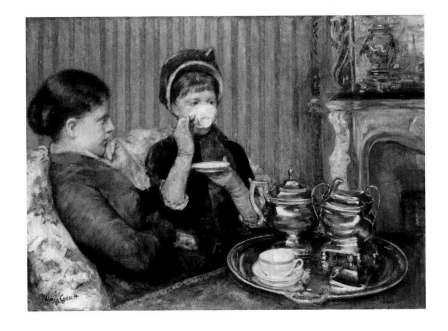

*Is femininity confirmed as passivity and masochism or is there a
critical look resulting from a different position from which
femininity is appraised, experienced and represented? In these
paintings by means of distinctly different treatments of those
protocols of painting defined as initiating modernist art – articula-
tion of space, repositioning of the viewer, selection of location,
facture and brushwork – the private sphere is invested with
meanings other than those ideologically produced to secure it as
the site of femininity. One of the major means by which feminin-
ity is thus reworked is by the rearticulation of traditional space so
that it ceases to function primarily as the space of sight for a
mastering gaze, but becomes the locus of relationships....There is
little extraneous space to distract the viewer from the inter-
subjective encounter...."[70]*

Pollock emphasizes "that the practice of painting is itself a site for the
inscription of sexual difference," but this need not exclude the argument
that a woman's life experience at a given place and time contributes to
the way certain artists have conceived and constructed space, the way
they "create their own world."[71] Perhaps like her nineteenth-century
predecessors, Neel sought to depict space differently from her male
contemporaries in order to register her specific experience of it. For
instance, because Neel considered urban space to be coextensive with
domestic space, her cityscapes are structured in a way which has little
to do with Hopper's "distancing and mastering gaze," despite their
stylistic parallels.

Recent scholarship on the historically neglected genre of still life has
served to expand Pollock's arguments. In the last of his series of four

essays on still-life painting in *Looking at the Overlooked*, Norman Bryson examines "…what the distinctions between low-plane reality and high-plane reality, between rhopography (dealing with the routines of daily living, the domestic round, the absence of individual uniqueness and distinction), and megalography (dealing with the narrative of History and the drama of greatness) imply in terms of the social construction of gender."[72] He argues that "the universe of rhopography, of creaturely limitation and low-plane reality, is not indifferently gendered: on average its delegates are far likelier to be women than men."[73] In general, the spaces in still lifes can be defined as feminine spaces: domestic interiors, frequently the kitchen, which at best relate only obliquely to the "real" (male) world outside. Like the spaces they depict, still-life paintings as a genre have frequently been the purview of women artists. "If still life could be regarded as an appropriate channel for female talent, this was because it ranked as the lowest form of artistic life…."[74] Ironically, the validity of this assertion may have been demonstrated by the fact that it was later turned inside out. In 1981, Lawrence Alloway argued that contemporary women painters deliberately adopted the "debased" style of realism and genre of still life in order to make a feminist art, a concept which may have occurred to Neel as early as 1930.[75]

In his otherwise illuminating study, Bryson's analysis deals in detail only with the male appropriation of this female "domain" and includes only a passing reference to women's contribution to the genre. The few lines devoted to Paula Modersohn-Becker make the brief suggestion that her "…emphasis on design is not at odds with the reality of the table as part of actual and everyday space. The hand which balances the formal composition is also able to reach out and make tea…."[76]

The adjectives which both Pollock and Bryson (and Alloway) use to describe "feminine space" are "intimate," "humble," "utilitarian," and "reflective of relationships," in contrast to the distancing, mastering, and abstracting male organization of space. The researches of psychologists such as Carol Gilligan and Mary Field Belenky have confirmed that these terms are applicable to females and males in their current social constructions. They provide evidence to argue that women's moral reasoning is based on experiential context and specific interpersonal relationships, whereas men's derives from a priori principles.[77] Their conclusions, drawn from extensive interviews, form a more practical base for speculation than the Procustean bed of French (Lacanian) psychoanalytic theory, which argues that within the phallocentric construction of Western culture, women can have no voice. But if such attributes are readily found in Neel's autobiographical still lifes, can they also be found in Neel's *Vanitas* still lifes, which treat the moralizing subject of "the passing of all things" in more traditional terms?

Figure 9
Haddock 1951
Hyman Bloom
oil on canvas
16 x 40"
Terry Dintenfass
Gallery, Inc.,
New York

Dead fish or fowl and human skulls are the objects used throughout the history of still-life painting to signal that "all is vanity." Neel's still lifes do not depart from traditional iconography, but three examples will show how they reinterpret the conventional display of decay. *Fish Still Life* (1945) initially recalls the ritual symbolism of the American expressionist Hyman Bloom's disintegrating *Haddock* (1951, fig. 9). While the mutilated body of the fish is a direct metaphor for the slaughter of World War II in both Bloom's *Haddock* and *Fish Still Life*, Neel's fish is depicted as part of the preparation of a meal, and the black cast-iron pan and the butcher knife on the counter at once further the metaphor and return it to the domestic arena. Bloom's "fish" is human flesh, and we do not connect it with dinner any more than, to quote Henry James, we would put "flesh and fish on the same platter."

In much the same way, the capon in *Thanksgiving* (1965) brings to mind the grisly lynched fowl of Chaim Soutine, but its naked, contorted body, stuffed ignominiously in the sink, is also viewed with a genuine humor lacking in most other twentieth-century *Vanitas* paintings: Only the hands which have pulled the viscera from the capon's cavity would depict Thanksgiving from the point of view of the victim of the victuals. Again, death is domesticated, made part of daily ritual.

Natura Morte from the same year is starker, recalling *Symbols* in its claustrophobic setting, bare table, and harsh light. But even here, the pre-Columbian skull, staring like one of Hopper's hypnotized figures out at the sunlight, is not isolated on its table/coffin; its body can be "re-assembled" by connecting the skull to the upright skeletal forms of the chair and radiator. Each of Neel's death symbols is really a portrait with a unique personality: death is not an abstract concept, but something which happens to individuals, something quite ordinary and inseparable from life. In *Mike Gold, In Memoriam* Neel places the portrait she made from life of the activist/author on a smaller table, arranging her houseplants at his "feet" to create another altar, the painting within the painting making explicit the theme of *ars longa, vita brevis*.

Admittedly, one can find a similar viewpoint in still lifes by men. Neel's debt to Van Gogh in this aspect of her work is much stronger than it is to a woman artist such as Cassatt. "Feminine" experience is not exclusive to women, nor is "feminine space" absent in art by men. Certainly Van Gogh's still lifes have as much "compositional intimacy" as Neel's, perhaps more if one compares his *Drawing Board, Onions, etc. Canvas* with its clutter of drawing implements and vegetables, with the abandoned onions in Neel's *Still Life, Spring Lake* (1969). Nevertheless, it is interesting that the paintings of later expressionists such as Kirchner or Kokoschka were informed primarily by the evidence of anxiety and alienation in Van Gogh's work, whereas Neel found in the same source intimacy and emphasis on dailiness.

If many of Neel's still lifes function as *Vanitas* paintings, her flower pieces are virtually all celebrations of nature's life force. Some owe more to the aestheticism of Matisse, others more to the vitalism of Van Gogh, but all of them speak to the ability of nature to flourish in a human context. The *Gladiolas*, springing from the tiny vase on the floor of Neel's living room with the energy of Van Gogh's *Irises* (1890, fig. 10), the philodendron whose spreading tendrils threaten to return 107th and Broadway to the wilderness, and the still life *Rose of Sharon,* in which summer's bounty, 'cropped' by the window shade, is captured and contained in a pitcher, are as expansive and sensuous as the cityscapes are barren and constricted.

Both Neel's exteriors and interiors imply a point of view, the space of her home/studio, which determines what is seen and what the work means.

Figure 10
Irises 1890
Vincent Van Gogh
oil on canvas
29 x 36 1/4"
Gift of Adele R. Levy
The Metropolitan Museum of Art,
New York

In both the exteriors and the interiors, the boundary between the outside and inside is left deliberately ambiguous. Exterior is simultaneously interior, just as the border of a cityscape is simultaneously a window frame, the painting's frame, and a frame of reference. The condensation of multiple meanings in single compositional elements is the means which permits her to work "away from situation," from the context of her personal life, to the making of metaphor. The stripped, "denatured" image, whose potential meanings are activated by the viewer, is the key to Neel's non-portrait work.

The very centrality of ambiguity in her work would seem to require that Neel's work no longer be placed in the straitjacket of categories. Stylistically, her art is "traditional" in its adherence to the conventions of realism. At the same time, in its belief that art is the expression of the individual sensibility, Neel's art belongs to the tradition of modernism. If her concept of self-expression, however, had little to do with the assertion of ego which characterizes so much of male-made twentieth-century art, her representation of a female point of view cannot legitimately be labelled "post-modernist," because she does not use her feminist viewpoint as a deliberate critical weapon. In sum, Neel's art does not "fit" established definitions, and when incorporating her art into the history of twentieth-century art, the historian must of necessity modify those definitions. Mainstream art history has not yet been up to that task, despite the fact that the importance of her art was established over a generation ago. Neel's art is only discussed in specialized "women's" texts and so her art has emerged from one pigeonhole – portraiture – only to be crammed into another which continues to marginalize it. One way out of the prison of categories is the consideration of Neel's contribution to the use of metaphor in twentieth-century art. In discussing the relation between metaphor and visual imagination, Paul Ricoeur cites Aristotle's description of the efficacy of metaphorical speech: "the vividness of...good metaphors consists in their ability to 'set before the eyes' the sense that they display."[78] Neel's cityscapes, landscapes, and still lifes are among the most vivid metaphors for lived experience in the art of our century, be it realist, modernist, or post-modernist.

Pamela Allara
Brandeis University

Endnotes

1 Ted Castle, "Alice Neel," *Artforum* XXI/11, October 1983, p. 41.

2 Quoted in Michael Baxandall, *Patterns of Intention*, New Haven, Yale University Press, 1985, p. 45.

3 In his letter of May 3, 1973, Baur wrote: "Our idea is that the exhibition should be retrospective and be limited strictly to portraits." Neel file, Whitney Museum of American Art, New York.

4 John Russell, "Alice Neel," *New York Times*, Friday, May 28, 1982, C23.

5 Jon Friedman, "Alice Neel," *Arts* 57/1, September 1982, p. 23.

6 Deborah Phillips, "Alice Neel," *ARTnews* 81/8, October 1982, p. 153.

7 Baxandall, op. cit., p. 43.

8 Russell, op. cit., C23.

9 Robert Storr, "Alice Neel at Robert Miller," *Art In America* 70/9, October, 1982, p.130.

10 Elaine Warren, "Alice Neel," *Los Angeles Herald Examiner*, April 5, 1983, C2.

11 Lucy Lippard, *From the Center: Feminist Essays on Women's Art*, 1976, quoted in Rozsika Parker and Griselda Pollock, *Old Mistresses: Women Art and Ideology*, New York, Pantheon Books, 1981, pp. 7–8.

12 Nearly all of Neel's biographers make this comparison. For instance, Patricia Hills has written that *Requiem* "has the quiet intensity of numbing grief found in some of Edvard Munch's work." (Patricia Hills, *Alice Neel*, New York, Abrams, 1983, p. 21. Hills' book is the definitive text on Alice Neel.) In her study of Neel's portraits, Ellen H. Johnson compared her with Van Gogh, adding the caveat that, "Neel's expressive strength could have been signalised by noting parallels with Munch, Kokoschka, or many other artists who have uncovered internal reality by recording and exaggerating external appearance. But whatever comparisons are made, they can only function as an accompaniment to the main theme of the artist's individual contribution." (Ellen H. Johnson, "Alice Neel's Fifty Years of Portrait Painting," *Studio International* 193, March, 1977, p. 176). Theodore Wolff also observed strong parallels with Van Gogh, writing in July, 1984 for the *Christian Science Monitor* an article entitled: "Will she be known as the American Van Gogh?"

13 The exhibition was organized by Frederick B. Deknatel of Harvard for the Institute of Contemporary Art in Boston and traveled to the Museum of Modern Art in New York. See: Reinhold Heller, "The Expressionist Challenge," in *Dissent: The Issue of Modern Art in Boston*. Boston, 1986, p. 47. Although Gustav Schiefler's two-volume catalogue raisonne of Munch's graphic work was published in Berlin in 1927, there is no evidence that Neel had access to a copy.

14 Belcher, Gerald and Margaret. *Collecting Souls, Gathering Dust: the struggles of two American Artists, Alice Neel and Rhoda Medary*. New York, Paragon House, 1991, p. 53.

15 Quoted in *Charles Burchfield, A Retrospective of Oils and Watercolors, 1916 – 43*. Buffalo, Albright Art Gallery, 1944, n.p.

16 William Jennings Bryant, *Bryant's Picturesque America*, vol.II, 1874, pp. 560 – 562.

17 See Milton Brown, "The Twenties," *American Painting From the Armory Show to the Depression*. Princeton, 1955, pp. 79 – 83.

18 Hills, op. cit., p. 97.

19 Ibid., p. 41.

20 For an exhaustive treatment of this subject see W. J. T. Mitchell, *Iconology*, Chicago, University of Chicago Press, 1986, and Wendy Steiner, *The Colors of Rhetoric: Problems in the Relation between Modern Literature and Painting*, Chicago, University of Chicago Press, 1982.

21 Lakoff and Johnson, *Metaphors We Live By*. Chicago, University of Chicago Press, 1980, p. 3.

22 Ibid., p. 118.

23 Ibid., p. 25.

24 Ibid., p. 30.

25 Norman Bryson, *Vision and Painting*. London, 1983, New Haven, 1985, p. 76.

26 Ibid., p. 70.

27 Theodore Dreiser, *Sister Carrie* (1917). Garden City, New York, pp. 98 – 99.

28 Hills, op. cit., p. 53.

29 Peggy Brooks, the painting's owner, pointed this out to me.

30 Mike Gold, *Jews without Money* (1930). New York, Avon Books, 1965.

31 For example, Berenice Abbott's "Shelter on the Waterfront," 1938, from the "Changing New York" series, also supported by New York City's Federal Art Project.

32 Allen Sekula, "Dismantling Modernism, Reinventing Documentary," first published in *Photography: Current Perspectives*, Jerome Liebling, ed. Amherst, The Massachusetts Review, 1978, p. 233.

33 Letter to Charles H. Sawyer, 29 October, 1939. Quoted in Gail Levin, *Edward Hopper: The Art and the Artist*. New York, Whitney Museum of American Art, 1981, p. 46.

34 Linda Nochlin, "The Flowering of American Realism," *Real, Really Real, Super Real, Directions in Contemporary American Realism*. San Antonio, Texas, San Antonio Museum of Art, 1981, p. 29.

35 Ibid., p. 25.

36 "Interview/Neel," Ibid., p. 47.

37 Geldzahler, "Alice Neel," *Interview* XV/I, January, 1985, p. 87.

38 Samuel Beckett, *Endgame*. New York, Grove Press, 1958, p. 1.

39 Ibid.

40 Jane Alison Hale, *The Broken Window: Beckett's Dramatic Perspective*. West Layfayette Indiana, Purdue University Press, p. 46.

41 Brooks Atkinson, "Savage Sunsets," The New York Times, 1951, quoted in *New York, An Anthology*, London, Cadogan Publications, 1985, p. 15.

42 Richard Pluntz, "Strange Fruit: The Legacy of the Design Competition in New York Housing," *If You Lived Here*, a project by Martha Rosler, Brian Wallis, ed. Dia Art Foundation, no. 6, 1990, pp. 129–130.

43 Hartley Neel, discussion with the author, New York City, June 1989.

44 Raymond Ledrut, "Speech and the Silence of the City," in *The City and the Sign: An Introduction to Urban Semiotics*, M. Gottdiener and A. Ph. Lagopoulous, eds. New York, Columbia University Press, 1986, p. 133.

45 Jane Jacobs, *The Death and Life of the Great American Cities*. New York, Random House, 1961, p. 37.

46 "The New York I Love: 17 New Yorkers tell us what makes them most love this big, bad, beautiful town," *New York Magazine*, October 20, 1980, pp. 34–37.

47 Ted Castle, "Alice Neel," op. cit., 41.

48 Hills, p. 185.

49 William Gerdts, *Painters of the Humble Truth: Masterpieces of American Still Life Painting*. Columbia, University of Missouri Press, 1981.

50 Charles Sterling, *Still Life Painting from Antiquity to the Twentieth Century*. 1952; rev. ed., 1981. New York, Harper & Row, p. 158.

51 May Stevens, "The non-portrait work of Alice Neel," *Women's Studies, An Interdisciplinary Journal*. London, 1978, p. 64.

52 Conversations with Marisa Diaz and her son Jose Peraza, longtime friends of Isabetta Enriquez, spring, 1991.

53 Hills, op. cit., p. 45.

54 Ibid. p. 29.

55 Lloyd Goodrich in *Arts*, January 1929, p. 9, quoted in Susan Noyes Platt, *American Modernism in the 1920s*. Ann Arbor, UMI Research Press, 1985, p. 105.

56 Storr, op. cit., p. 130.

57 Hayden Herrera, *Frida, a Biography of Frida Kahlo*. New York, Harper Colophon, 1983, p. 141.

58 Ibid.

59 Ibid., p. 151.

60 Hills, p. 70.

61 Stevens, op. cit., p. 63.

62 Ibid., p. 61.

63 Nochlin, *Women, Art, and Power and Other Essays*. New York, Harper & Row, 1988, p. 99.

64 Castle, op. cit., p. 41.

65 Stevens, op. cit., p. 64.

66 Wallace Stevens, *Collected Poems*. New York, Alfred A. Knopf, 1957, p. 76.

67 Linda Weintraub, ed., *Art What Thou Eat*, Annendale-on-Hudson, Bard College, 1991, p. 49.

68 Alice Neel, Doctoral Address, Moore College of Art, June 1, 1971, quoted in Hills, p. 134.

69 See Johanna Frueuh and Arlene Raven, eds. "Feminist Art Criticism," *Art Journal* 50/2, Summer 1991.

70 Griselda Pollock, "Modernity and the Spaces of Femininity," *Vision and Difference*. New York and London, Routledge, 1988, p. 87.

71 Francine du Plessix Grey has argued that art by women reflects a female's experience, even though there is no female style or manner. See *The Helcion Nine: A Journal of Women's Art and Letters*, Kansas City, Missouri, 1979.

72 Norman Bryson, *Looking at the Overlooked: Four Essays on Still Life*. Cambridge, Harvard University Press, 1990, p. 15.

73 Ibid., p. 158.

74 Ibid., p. 175.

75 Lawrence Alloway, "The Renewal of Realist Criticism," *Art In America* 68/7, September, 1981, p. 110.

76 Bryson, op. cit., p. 165.

77 Mary Field Belenky, et. al., *Women's Ways of Knowing*, New York, Harper Collins, 1986, p. 8.

78 Paul Ricoeur, "The Metaphorical Process," *On Metaphor*. Sheldon Sacks, ed. Chicago, University of Chicago Press, 1979, p. 142.

Selected Works from the Exhibition

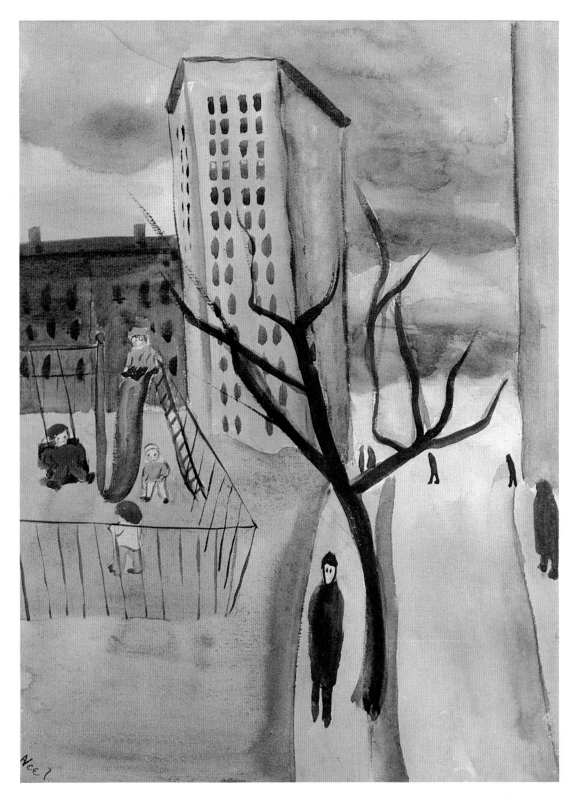

Plate 1
After the Death of the Child 1927
watercolor on paper
11 3/4 x 8 3/4"
Collection of Peggy Brooks

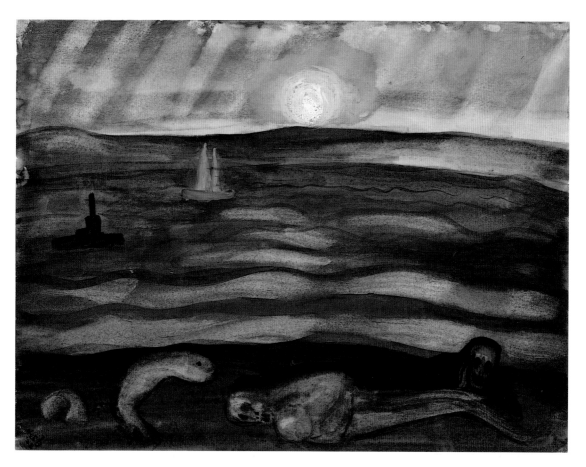

Plate 2
Requiem 1928
watercolor on paper
9 x 12"
Robert Miller Gallery, New York

Plate 3
Harlem River 1927
watercolor on paper
14 1/2 x 19 3/4"
Robert Miller Gallery, New York

Plate 4
Classic Fronts 1930
oil on canvas
24 x 20"
Robert Miller Gallery, New York

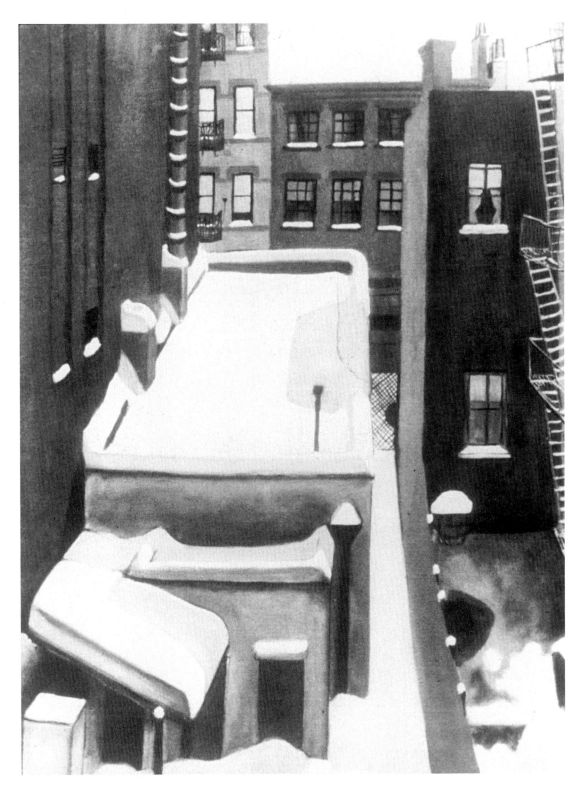

Plate 5
Snow on Cornelia Street 1933
oil on canvas
30 x 24"
Collection of Peggy Brooks

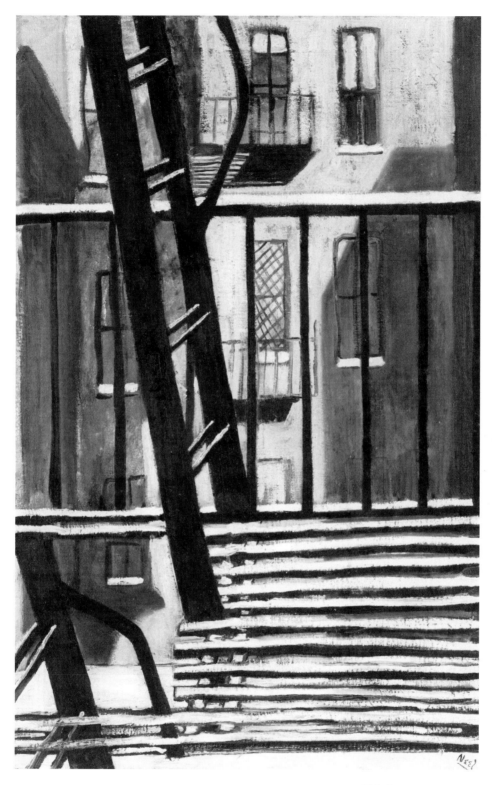

Plate 6
Fire Escape 1946
oil on canvas
36 x 24"
Collection of Peggy Brooks

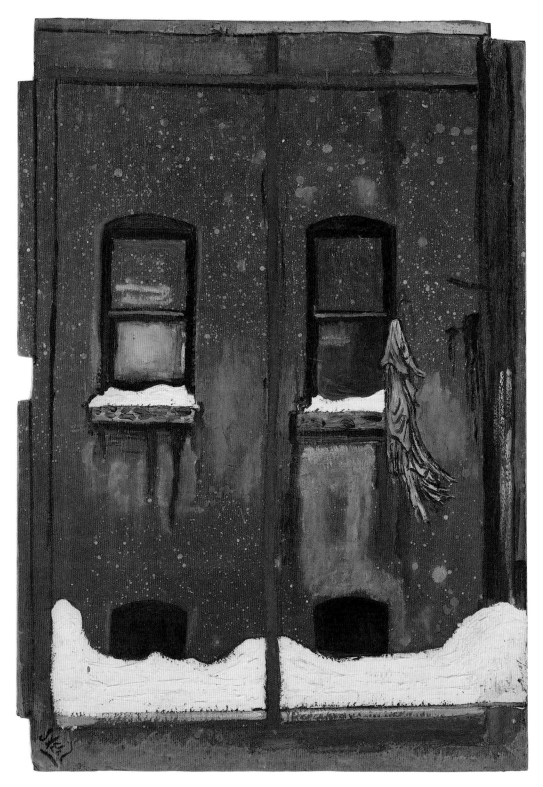

Plate 7
Rag in Window 1959
oil on panel
33 x 24"
Collection of Arthur Bullowa

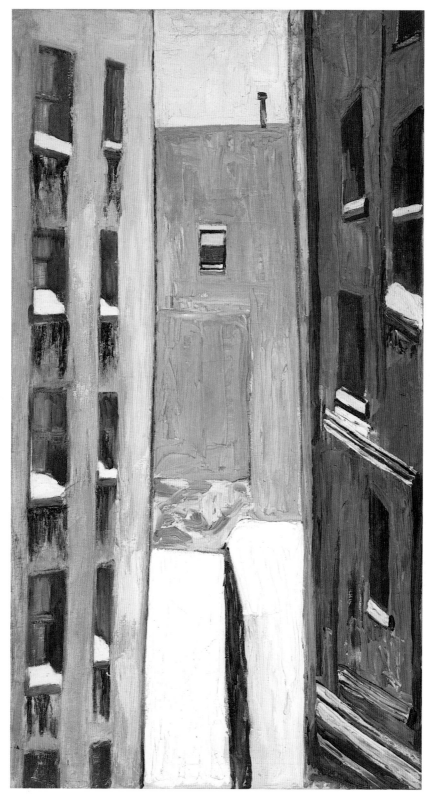

Plate 8
Snow 1964
oil on canvas
47 x 26"
Robert Miller Gallery, New York

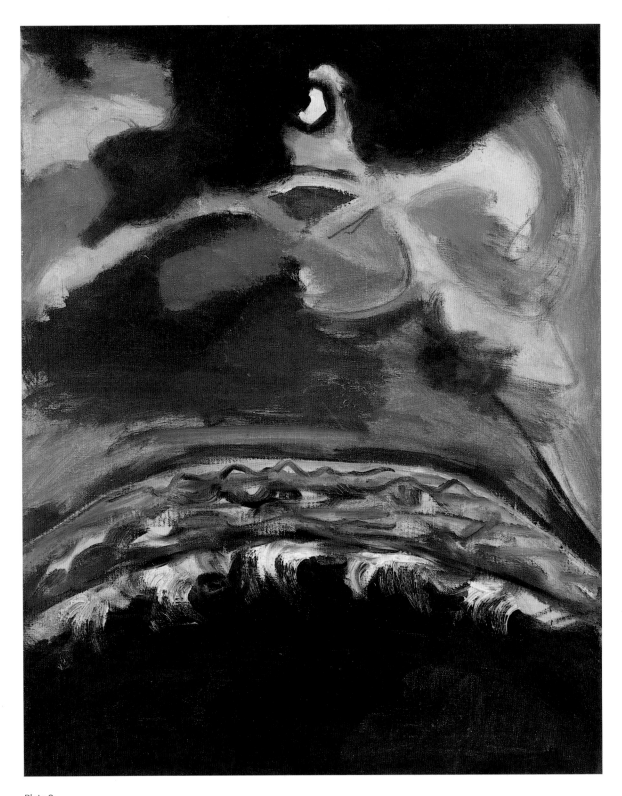

Plate 9
The Sea 1947
oil on canvas
30 x 24"
Robert Miller Gallery, New York

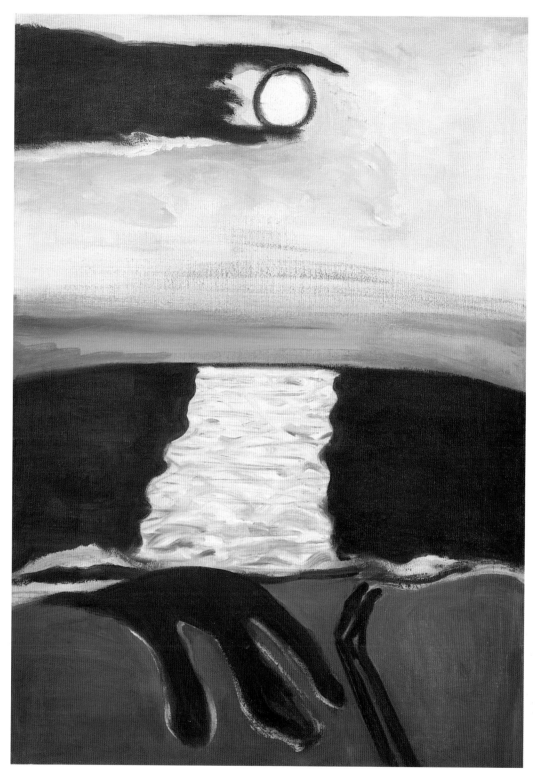

Plate 10
Cutglass Sea 1947
oil on canvas
28 x 20"
Robert Miller Gallery, New York

Plate 11
Sunset in Spanish Harlem 1958
oil on canvas
39 x 22"
Collection of The Equitable, New York

Plate 12
Cityscape 1968
oil on canvas
50 x 46"
Robert Miller Gallery, New York

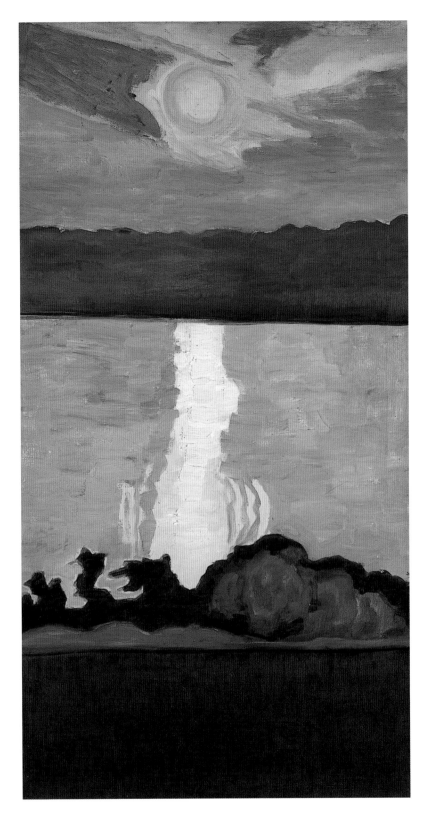

Plate 13
Sunset, Riverside Drive 1957
oil on canvas
50 x 26"
Robert Miller Gallery, New York

Plate 14
Eclipse 1964 –1965
ink and pastel on paper
14 1/2 x 11"
Robert Miller Gallery, New York

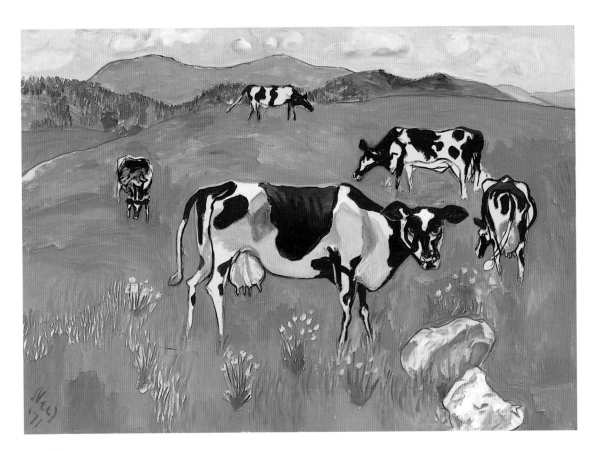

Plate 15
Cows, Vermont 1971
oil on canvas
36 x 50"
Collection of Marilyn and Bernard Pincus

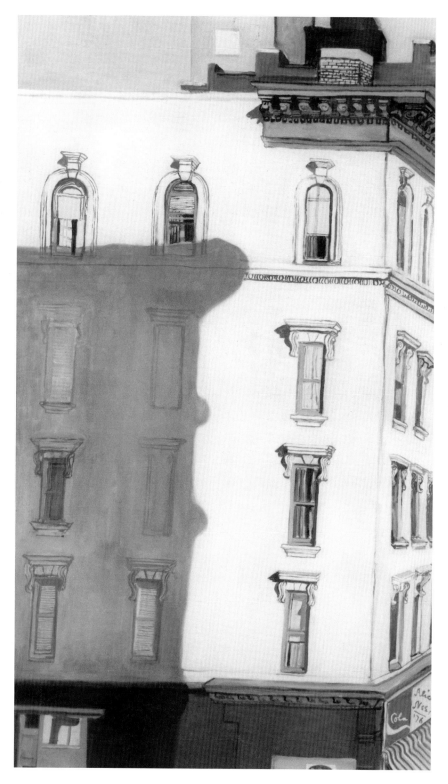

Plate 16
107th and Broadway 1976
oil on canvas
60 x 34"
Private collection

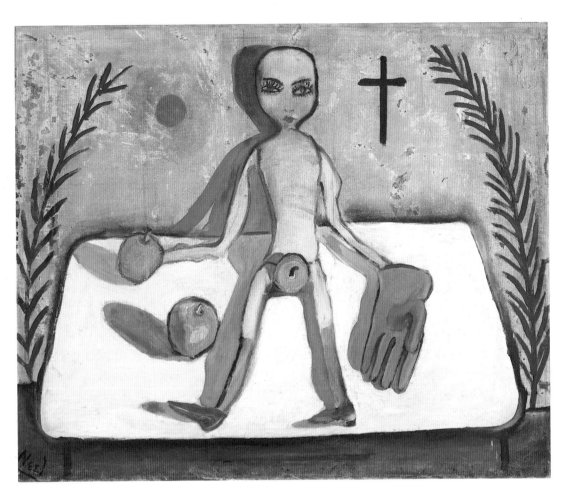

Plate 17
Symbols (Doll and Apple) 1932
oil on canvas
23 x 28"
Robert Miller Gallery, New York

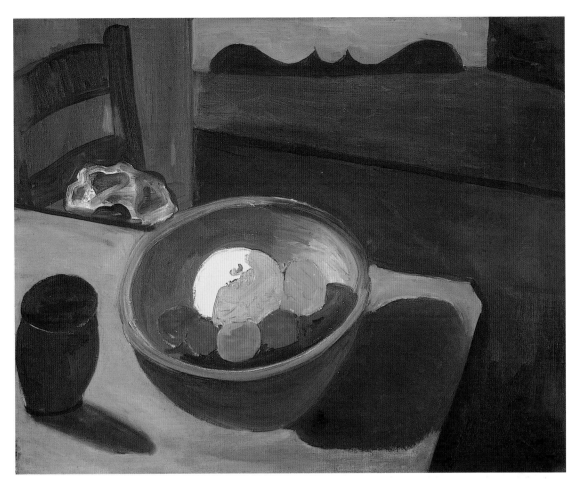

Plate 18
Still Life With Fruit 1940
oil on canvas
24 x 30"
Collection of Arthur Bullowa

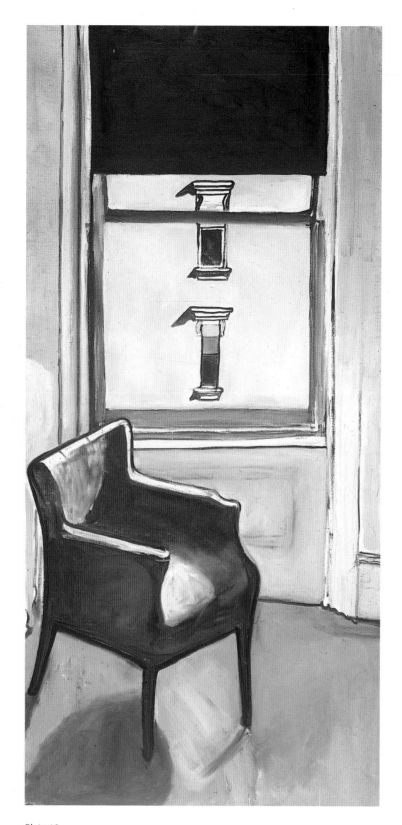

Plate 19
Loneliness 1970
oil on canvas
80 x 38"
Collection of Arthur Bullowa

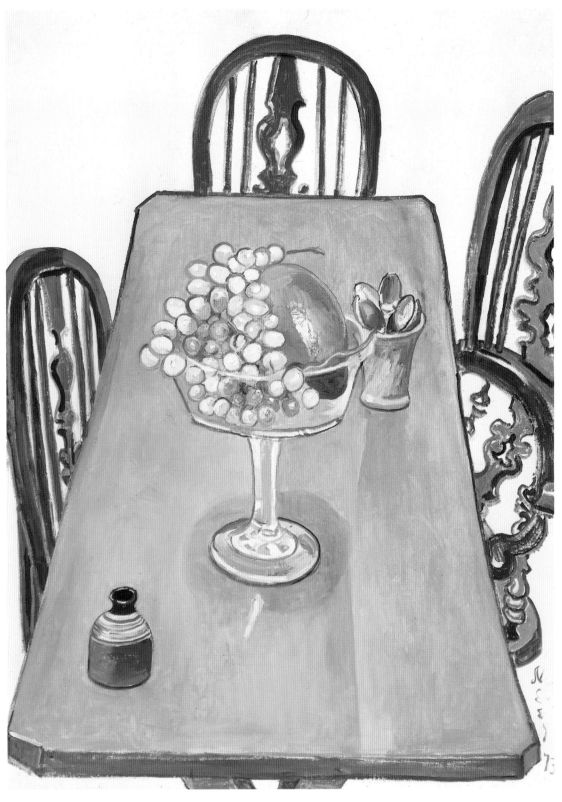

Plate 20
Jar From Samarkand 1973
oil on canvas
44 x 32"
Private collection

Plate 21
Still Life, Black Bottles 1977
oil on canvas
40 x 30"
Collection of The Equitable, New York

Plate 22
Cut Glass With Fruit 1952
oil on canvas
21 x 31"
Robert Miller Gallery, New York

Plate 23
Still Life (White Window) 1958
oil on canvas
20 x 24"
Collection of Wendy Williams

Plate 24
Fish Still Life 1945
oil on canvas
18 x 22"
Robert Miller Gallery, New York

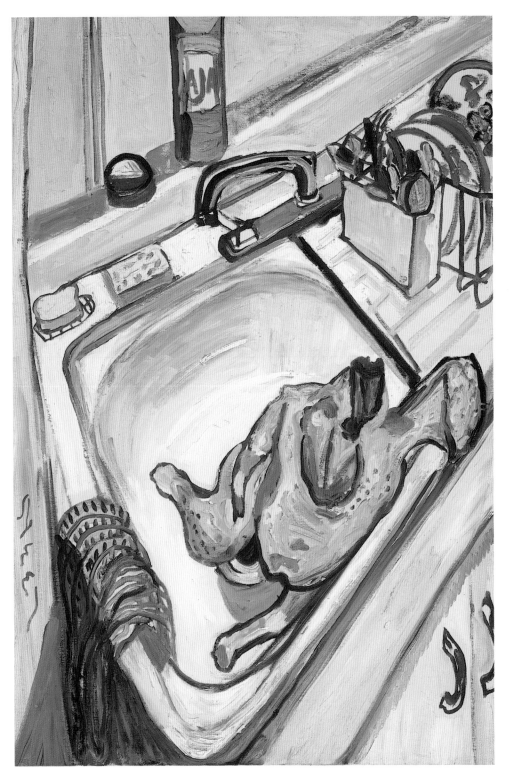

Plate 25
Thanksgiving 1967
oil on canvas
30 x 24"
Private collection

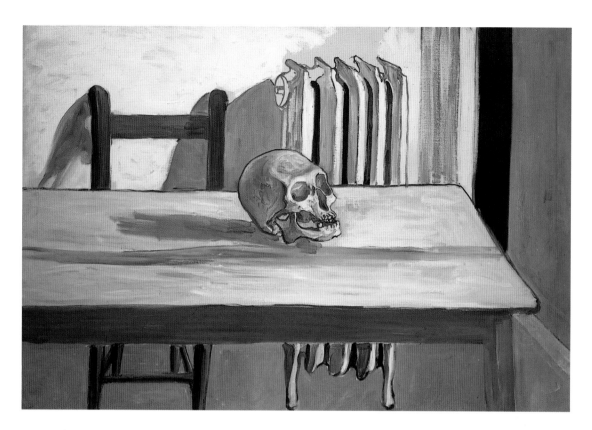

Plate 26
Natura Morte 1964 – 65
oil on canvas
31 x 45"
Robert Miller Gallery, New York

Plate 27
Mike Gold, In Memoriam 1967
oil on canvas
54 x 34"
Robert Miller Gallery, New York

Plate 28
Gladiolas 1974
oil on canvas
40 x 30"
Collection of Arthur Bullowa

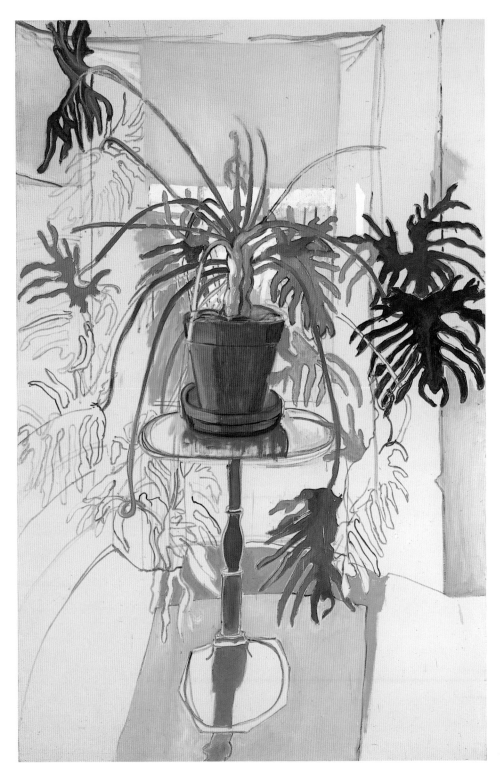

Plate 29
Philodendron 1970
oil on canvas
80 x 52"
Private collection

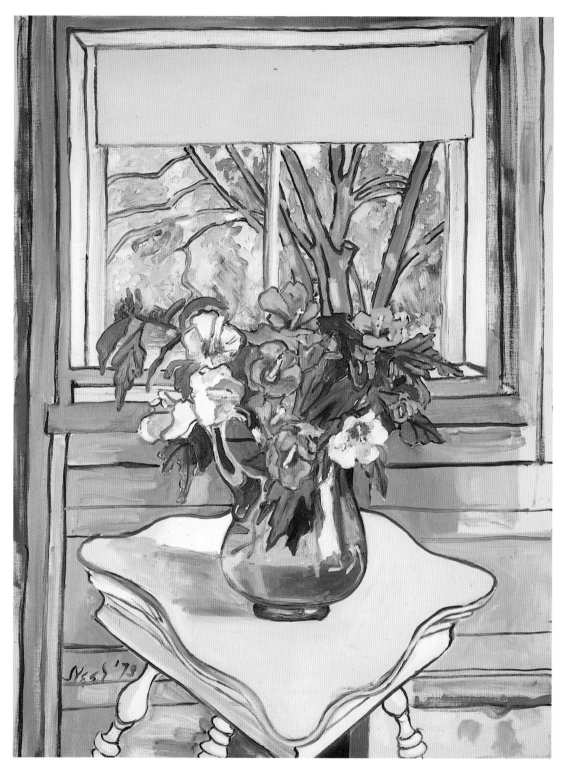

Plate 30
Still Life, Rose of Sharon 1973
oil on canvas
40 x 30"
Collection of Arthur Bullowa

Catalog of the Exhibition

1
Still Life, Havana 1926
oil on canvas
25 7/8 x 20 1/8"
Robert Miller Gallery, New York

2
After the Death of the Child 1927
watercolor on paper
11 3/4 x 8 3/4"
Collection of Peggy Brooks

3
Waterfront 1927
watercolor on paper
9 x 12"
Robert Miller Gallery, New York

4
Evening in Riverside Park 1927
watercolor on paper
9 x 11 3/4"
Robert Miller Gallery, New York

5
Harlem River 1927
watercolor on paper
14 1/2 x 19 3/4"
Robert Miller Gallery, New York

6
Requiem 1928
watercolor on paper
9 x 12"
Robert Miller Gallery, New York

7
Classic Fronts 1930
oil on canvas
24 x 20"
Robert Miller Gallery, New York

8
Symbols (Doll and Apple) 1932
oil on canvas
23 x 28"
Robert Miller Gallery, New York

9
Snow on Cornelia Street 1933
oil on canvas
30 x 24"
Collection of Peggy Brooks

10
Snow Scene 1933
oil on canvas
30 x 26"
Robert Miller Gallery, New York

11
9th Avenue El 1935
oil on canvas
24 x 30"
Robert Miller Gallery, New York

12
Snow 1935
oil on canvas
25 x 23"
Collection of Elizabeth B. Shackelford

13
Night 1936
watercolor on paper
12 x 9"
Private collection

14
Still Life With Fruit 1940
oil on canvas
24 x 30"
Collection of Arthur Bullowa

15
Still Life With Decoys 1940
oil on canvas
19 1/2" x 25"
Robert Miller Gallery, New York

16
Fish Still Life 1945
oil on canvas
18 x 22"
Robert Miller Gallery, New York

17
Dead Pigeon c. 1945
oil on canvas
16 x 20"
Collection of Joel Rothschild

18
Fire Escape 1946
oil on canvas
36 x 24"
Collection of Peggy Brooks

19
Glass Dish With Fruit 1946
oil on canvas
16 x 20 1/2"
Collection of Elizabeth B. Shackelford

20
Cutglass Sea 1947
oil on canvas
28 x 20"
Robert Miller Gallery, New York

21
The Sea 1947
oil on canvas
30 x 24"
Robert Miller Gallery, New York

22
Fall Flowers on White Table 1947
oil on canvas
34 x 27"
Robert Miller Gallery, New York

23
Fire Escape 1948
oil on canvas
34 x 25"
Robert Miller Gallery, New York

24
Harlem Nocturne 1952
oil on canvas
24 x 21"
Robert Miller Gallery, New York

25
Cut Glass With Fruit 1952
oil on canvas
21 x 31"
Robert Miller Gallery, New York

26
Tree-Atco, New Jersey 1955
ink on paper
16 1/2 x 14"
Collection of Wendy Williams

27
Sunset, Riverside Drive 1957
oil on canvas
50 x 26"
Robert Miller Gallery, New York

28
Falling Tree 1958
oil on masonite
28 x 40"
Collection of Betty Comden Kyle

29
Tree, Spring Lake, c. 1958
oil on canvas
46 1/2 x 26 3/4"
Collection of Stewart R. Mott

30
Sunset in Spanish Harlem 1958
oil on canvas
39 x 22"
Collection of The Equitable, New York

31
Still Life (White Window) 1958
oil on canvas
20 x 24"
Collection of Wendy Williams

32
Rag in Window 1959
oil on panel
33 x 24"
Collection of Arthur Bullowa

33
Rag in Window 1959
ink on paper
12 1/2 x 9 3/8"
Robert Miller Gallery, New York

34
Night 1959
oil on canvas
32 x 18"
Robert Miller Gallery, New York

35
Snow 1964
oil on canvas
47 x 26"
Robert Miller Gallery, New York

36
Eclipse 1964
oil on canvas
46 x 31"
Robert Miller Gallery, New York

37
Plant in Window 1964
ink on paper
12 x 8 3/4"
Robert Miller Gallery, New York

38
Natura Morte 1964 – 65
oil on canvas
31 x 45"
Robert Miller Gallery, New York

39
Still Life c. 1964
oil on canvas
50 x 27"
Collection of Katharine Cole

40
Eclipse 1964 –1965
ink and pastel on paper
14 1/2 x 11"
Robert Miller Gallery, New York

41
Thanksgiving 1965
oil on canvas
30 x 24"
Private collection

42
Snow 1967
oil on canvas
80 x 60"
Collection of Katharine Cole

43
Mike Gold, In Memoriam 1967
oil on canvas
54 x 34"
Robert Miller Gallery, New York

44
Cityscape 1968
oil on canvas
50 x 46"
Robert Miller Gallery, New York

45
New York in the Rain c. 1968
oil on canvas
28 x 30"
Robert Miller Gallery, New York

46
Still Life, Spring Lake 1969
oil on canvas
30 x 40"
Robert Miller Gallery, New York

47
Loneliness 1970
oil on canvas
80 x 38"
Collection of Arthur Bullowa

48
Philodendron 1970
oil on canvas
80 x 52"
Private collection

49
Cows, Vermont 1971
oil on canvas
36 x 50"
Collection of Marilyn and Bernard Pincus

50
Jar From Samarkand 1973
oil on canvas
44 x 32"
Private collection

51
Still Life, Rose of Sharon 1973
oil on canvas
40 x 30"
Collection of Arthur Bullowa

52
Gladiolas 1974
oil on canvas
40 x 30"
Collection of Arthur Bullowa

53
107th and Broadway 1976
oil on canvas
60 x 34"
Private collection

54
Windows 1977
oil on canvas
60 x 40"
Collection of Toni S. Schulman

55
Still Life, Black Bottles 1977
oil on canvas
40 x 30"
Collection of The Equitable, New York

56
Lilacs 1983
oil on canvas
50 x 38"
Robert Miller Gallery, New York

PHOTO CREDITS

Figures: 1 *Scala/Art Resource, N.Y.;*
2 *Taylor and Dull, Inc;* 3 *Geoffrey
Clements;* 4 *Geoffrey Clements;*
5 *Addison Gallery of American Art, Phillips
Academy;* 6 *Kennedy Galleries, Inc.;*
7 *Javier Hinojosa;* 8 *Museum of Fine
Arts, Boston;* 9 *Douglas Baz;* 10 *The
Metropolitan Museum of Art.*

Plates: 1 *Zindman/Freemont;* 2 *Zindman/
Freemont;* 3 *Zindman/Freemont;* 4 *Beth
Phillips;* 5 *Jonathan Brand;* 6 *Steven
Sloman;* 7 *Beth Phillips;* 8 *Robert Miller
Gallery;* 9 *Robert Miller Gallery;*
10 *Phillips/Schwab;* 11 *Robert Miller
Gallery;* 12 *Zindman/Freemont;* 13 *Robert
Miller Gallery;* 14 *Zindman/Freemont;*
15 *Zindman/Freemont;* 16 *Eric Pollitzer;*
17 *Phillips/Schwab;* 18 *Steven Sloman;*
19 *Steven Sloman;* 20 *Phillips/Schwab;*
21 *Robert Miller Gallery;* 22 *Robert Miller
Gallery;* 23 *James Dee;* 24 *Robert Miller
Gallery;* 25 *Steven Sloman;* 26 *Zindman/
Freemont;* 27 *Beth Phillips;* 28 *Robert
Miller Gallery;* 29 *Robert Miller Gallery;*
30 *Steven Sloman.*

NB: Reproduction of the work of Frida
Kahlo was authorized by the Instituto
Nacional de Bellas Artes y Literatura.

PUBLICATION CREDITS

Publication Coordinator *Suzanne Perry*
Design *Alison Kennedy and Margaret Bauer
for WGBH Design*
Copy Editor *Frederick Kalil*
Linotronic output *Typographic House*
Printing *LaVigne Press*
The text of this catalog was set in Syntax
with Gill Sans Extra Bold heads. The display
type is Garamond Italic. The cover paper is
Strathmore Grandee, the text paper is
Patina 100 lb. text.